C000066501

SUDBURY, LONG MELFORD & LAVENHAM
THROUGH TIME
Kate J. Cole

AMBERLEY

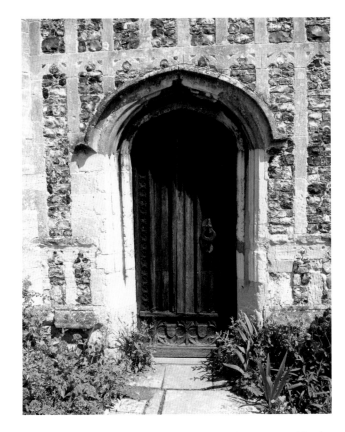

Doorway to the ancient Lady Chapel, at Holy Trinity Church, Long Melford

This book is dedicated to the memory of R. C. 'Bob', a giant of a man with the kindest of hearts, who taught me how to appreciate the big skies of Suffolk.

First published 2015

Amberley Publishing
The Hill, Stroud, Gloucestershire, GL5 4EP
www.amberley-books.com

Copyright © Kate J. Cole, 2015

The right of Kate J. Cole to be identified as the
Author of this work has been asserted in accordance with
the Copyrights, Designs and Patents Act 1988.

ISBN 978 1 4456 3680 1 (print)
ISBN 978 1 4456 3696 2 (ebook)

All rights reserved. No part of this book may be reprinted
or reproduced or utilised in any form or by any electronic,
mechanical or other means, now known or hereafter
invented, including photocopying and recording, or in
any information storage or retrieval system, without the
permission in writing from the Publishers.

British Library Cataloguing in Publication Data.
A catalogue record for this book is available from the
British Library.

Typesetting by Amberley Publishing.
Printed in Great Britain.

Contents

Acknowledgements

I would like to thank the readers of my blog, www.essexvoicespast.com, and my connections on twitter through @EssexVoicesPast who have encouraged me throughout my time writing this book.

Dates attributed to postcards are based on postmarks and/or dates the photographers were active and/or serial numbers on the postcards. Postmarks can only ever be a rough estimate of the date of the postcard – sometimes people purchased postcards but used them many years later, or shops kept old stock for many years. Therefore postmarks are only ever the last possible date of that postcard's view.

Every attempt has been made to seek permission for copyright material used in this book. However, if we have inadvertently used copyright material without permission/ acknowledgement we apologise and we will make the necessary correction at the first opportunity.

Introduction

In 1086, twenty years after the Norman Conquest, King William I sent out his men throughout his new English kingdom to determine how much tax each landholder owed him. In Sudbury, in the Hundred of Thingoe, his men found that there were approximately 129 households (this included 118 burgesses, two villeins, and two serfs), thirty-four acres of meadow land, one mill, one church, and nearly half an acre of church lands. The king himself was the lord of the manor, having deprived the Countess Aelfeva of the manor of Sudbury sometime after 1066. In Lavenham, in Babergh Hundred, there were sixty-six households (including one freeman, seven villeins, forty-three smallholders and six serfs), with thirteen acres of meadows, a hundred pigs in woodland, one mill, twenty-five cattle, sixty-five other pigs, two-hundred sheep, eighty goats and six beehives. The overlord of Lavenham in 1066 had been King Edward the Confessor; by 1086 it was Aubrey de Vere, who had followed William to England from Normandy. Long Melford, also in the Hundred of Barbergh, had seventy-eight households (including two freeman, forty-one villeins, nineteen smallholders and sixteen serfs), with fifty acres of meadows, sixty pigs in woodland, two mills, two church lands, three cobs (horses), thirty cattle, one-hundred and forty other pigs, and three-hundred sheep. Its lord of the manor was the Abbey at Bury St Edmunds. All three places were very large for their time with many resources and possessions.

Nearly a thousand years on and those statistics have changed considerably in the twenty-first century. Unsurprisingly, each area has new assets to attract its inhabitants and visitors. Sudbury boasts its heritage of Thomas Gainsborough, silk-weaving and silk factories, and the tranquil beauty of the River Stour meandering through Sudbury's famous water meadows.

Lavenham, built on the wealth of the medieval wool trade and once the fourteenth wealthiest town in England, where magnificent medieval guildhalls coexist alongside nineteenth-century industrial factories. Long Melford, whose own industrial past harmonises with its late medieval church and two Tudor manor houses.

Sudbury, Long Melford and Lavenham are three impressive jewels in Suffolk's crown of splendid towns and villages, with each area attracting thousands of visitors each year. Through the pages of this book, I hope you will enjoy these remarkable Suffolk treasures as you wander each town through time.

Kate Cole
Maldon, Essex – Summer 2015
www.essexvoicespast.com

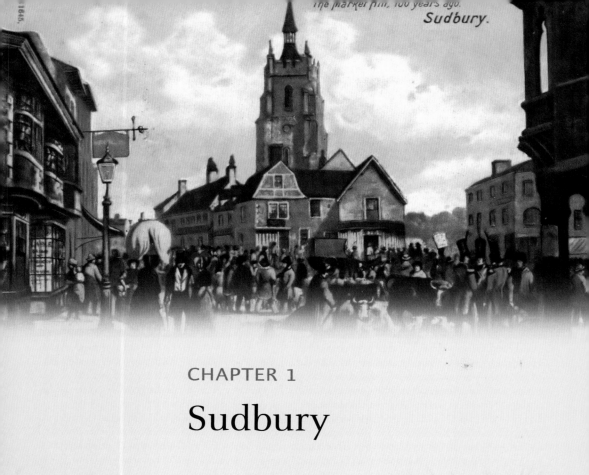

CHAPTER 1

Sudbury

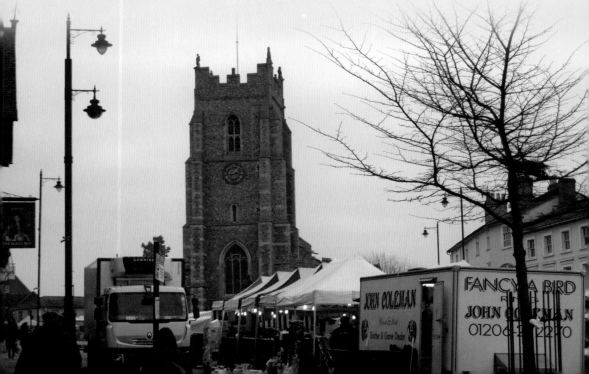

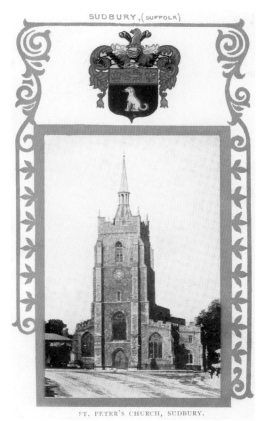

ST. PETER'S CHURCH, SUDBURY.

St Peter's Church, *c.* Early 1900s

One of the most recognised landmarks in Sudbury is the church of St Peter's on Market Hill. Originally built in the medieval period as a chapel to nearby St Gregory's church, St Peter's was not a parish church (at no time has there been a Sudbury parish of St Peter's), but, instead, it was a 'chapel of ease' for the parishioners of St Gregory's. Funded by local guilds and townspeople, St Peter's was built during the fourteenth and fifteenth centuries. The church closed for regular public worship in 1971, and its ownership passed to the Churches Conservation Trust. Although now closed for regular public services, the church is often used for weddings, funerals, and joint religious services with other local churches. It is also used as a venue for secular events (such as concerts, flower shows, and craft events). Since 2012, it has been used to hold a splendid farmers' market each month.

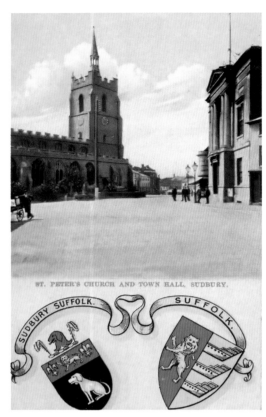

ST. PETER'S CHURCH AND TOWN HALL, SUDBURY.

St Peter's Church and Town Hall, from the Old Market Place, Postmarked 1913
Sudbury was first granted a charter to hold a market sometime at the beginning of the eleventh century, the precise date of this charter is unknown. Originally the market was held in Stour Street, but it moved to the area surrounding St Peter's church sometime in the fourteenth century. In medieval times, the area between the church and the town hall held the butter market, along with stalls or shops for the leather sellers and shoemakers. By the 1820s, adverts in local newspapers were referring to this area as the Old Market Place.

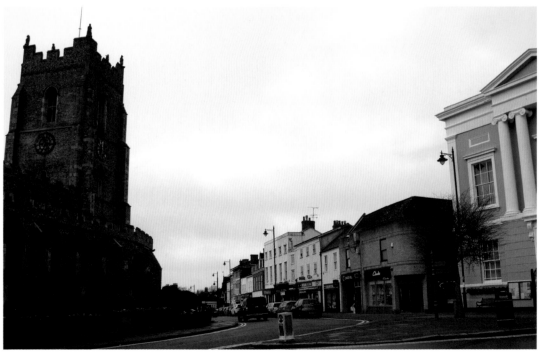

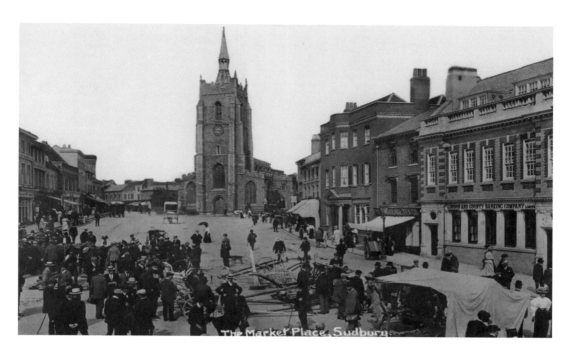

The Market Place, Postmarked 1912

Since the 1820s, Sudbury's market has been held mainly in the area at the front of the church; although, today, sections of it still spill over into the Old Market Place outside the town hall. The market has always been a busy trading area, attracting buyers and sellers from miles around, who travelled into the town from many outlying towns and villages across Suffolk and Essex. The market sold livestock, agricultural and farm produce, along with other market produce and goods.

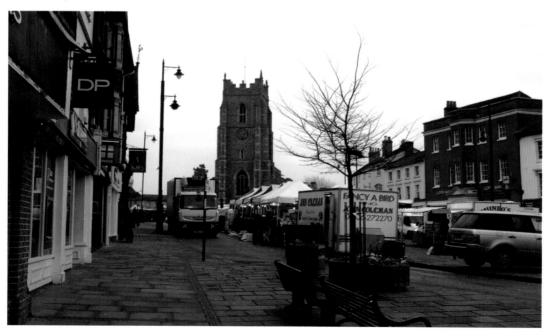

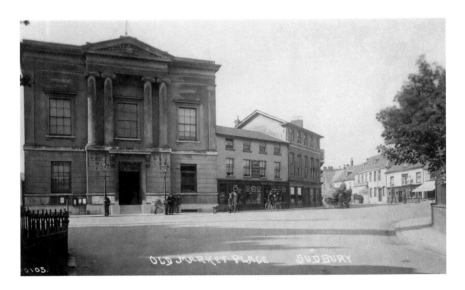

Town Hall, *c.* 1910s

On 20 May 1825, the Sudbury Improvement Bill received royal assent. Locally, the bill was highly contentious and controversial because of perceived fears by some local freeman that they would lose some of their ancient rights, such as the right to graze their flocks on open arable fields. However, the bill also included improvements such as the paving, lighting and general improvement to Sudbury. The town hall was built as part of that improvement. In March 1828, local newspapers reported that Mr Thomas Ginn Jr, an architect from Sudbury, had been awarded ten guineas by the Corporation for the best plan of the proposed town hall. In June 1830, newspapers reported that the town hall and gaol had been built by Mr Ginn at the expense of £2,500. The new town hall consisted of a Court of Session room (to hold the quarterly assizes), a council chamber, an assembly room and a retiring room. The gaol, although small, was large enough to house four cells, a yard and a governor's house. The Georgian town hall is now the offices of Sudbury Town Council, and the site of the gaol is now the town's heritage centre.

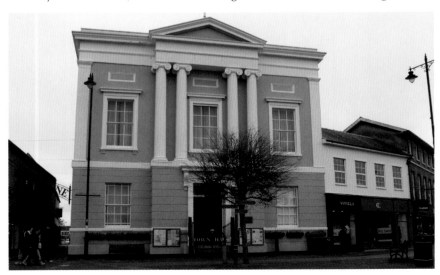

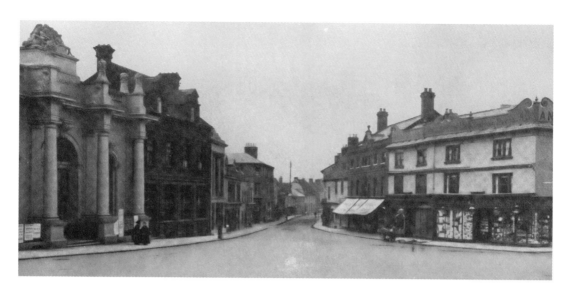

Market Hill, c. Early 1900s

Talk of building a corn exchange was first raised in the local newspapers in December 1840. Financed by subscribers, interested parties were requested to submit their plans and tenders to the committee by 9 June 1841. On Thursday 5 August, a tender was accepted for £1,620 from Mr Webb, a builder from Long Melford who used the London architect H. E. Kendall. On Monday 9 August 1841, the foundations for the new corn exchange commenced. A year later, one of the corn exchange's first use was the venue for the September 1842 Sudbury Horticultural Society's show. That same month, twenty-four standings in the corn exchange, along with cellars under the building and two rooms at the end of the Exchange, were let by public auction. Then followed over a hundred years of the building's use as the town's corn exchange, until the 1960s marked the end of its original function. Fortunately it was saved from demolition, and in the 1960s was converted into the town's well-stocked library, which also houses a first-class holding of local and family history resources.

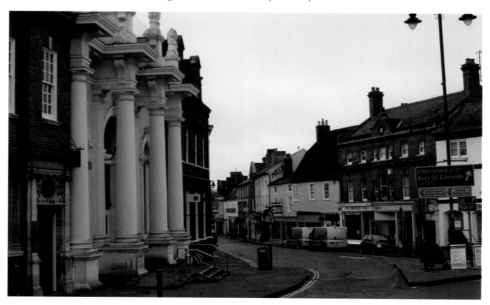

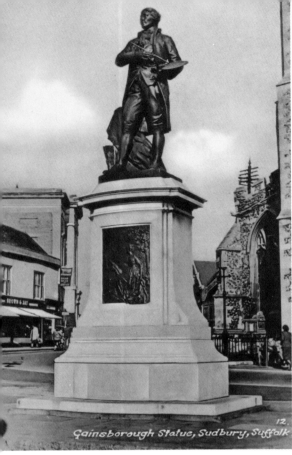

Gainsborough Statue, Sudbury, Suffolk

Gainsborough's Statue, Outside St Peter's Church, *c.* 1920s

Immediately outside St Peter's church is the statue of Sudbury's most famous son, the landscape and portrait artist, Thomas Gainsborough (1727–88), who was born in Sepulchre Street (now Gainsborough Street). As a child, Gainsborough attended nearby Sudbury Grammar School, which was then under the headmastership of his maternal uncle, the Revd Humphrey Burroughs. At the age of thirteen, Gainsborough left Sudbury to learn his craft as an artist in London, where in 1746 he married Margaret Burr. According to some rumours, she was the illegitimate child of the 3rd Duke of Beaufort. Gainsborough and his wife returned to Sudbury in 1748/49, shortly after the death of his father. They remained in Sudbury until about 1752 after which time, they moved first to Ipswich and then onto Bath and finally settled in London. Gainsborough died in London in August 1788 and was buried in St Anne's churchyard in Kew. His impact on Sudbury, and the high regard the town still holds for him, is reflected throughout the area by the names of some local roads and community buildings.

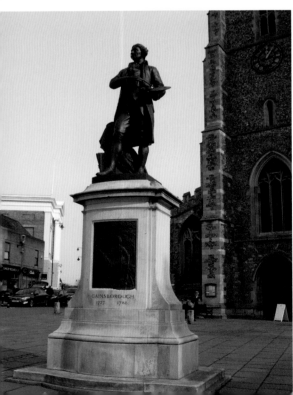

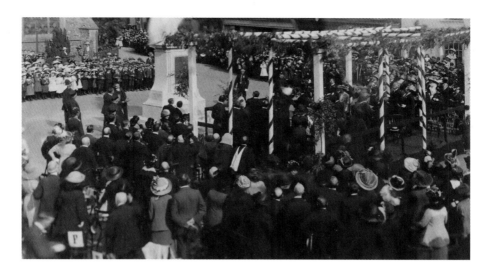

Unveiling of Gainsborough's Statue by Princess Louise, 10 June 1913

The bronze statue of Thomas Gainsborough was crafted by the Australian sculptor Bertram Mackennal (1863–1931). It was unveiled by the Duchess of Argyll (Princess Louise, Queen Victoria's sixth child), on the 10 June 1913 at a grand ceremony witnessed by the entire town. Many people were present; from the leaders of Suffolk and Sudbury, to tiny schoolchildren in their Sunday best. The entire area around the market place was bedecked with flags and bunting; and people hung out of the windows to watch the unveiling. The Duchess unveiled the statue by pulling on a piece of rope attached to the cloth covering Gainsborough. Unfortunately, the cloth became caught up on Gainsborough's artist's palette, leading to the statue having to be finally unveiled by a local painter and decorator using a ladder. Exactly one hundred years later, Gainsborough's House Museum organised a re-enactment of Princess Louise's unveiling, complete with the cloth becoming (accidentally) stuck. Inset: Princess Louise, Duchess of Argyll.

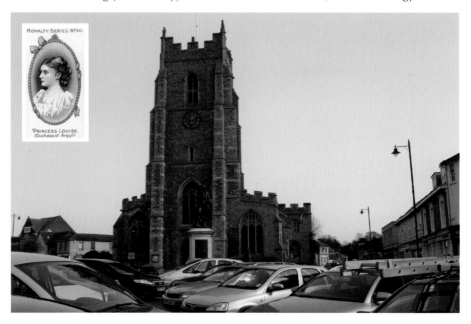

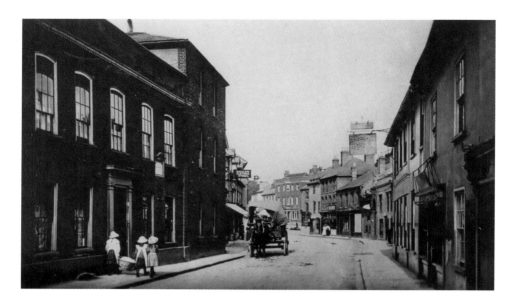

Gainsborough Street, Early 1910s

Originally known as Sepulchre Street, the road was renamed to Gainsborough Street sometime between 1894 and 1898, in honour of Sudbury's famous son. Gainsborough's House (on the left) was purchased by the Gainsborough's House Society in 1958. The Society was formed specifically to purchase the artist's birthplace and establish his house as a permanent museum dedicated to Gainsborough. The museum first opened its doors in 1961. Parts of the house, notably the oak doorway in the entrance room, are thought to date back to the 1490s. Gainsborough's father, John Gainsborough, added the red brick façade (still present today) sometime in the 1720s. Inset: An impression of Gainsborough birthplace in 1727 (before the brick façade was built) by engraver George C Finden (1811–85).

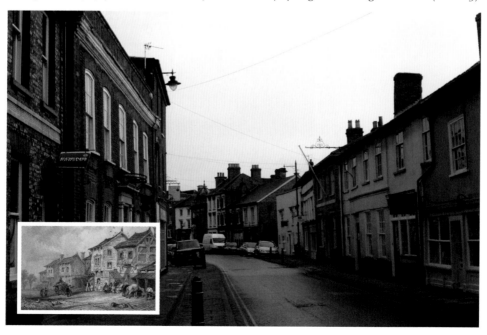

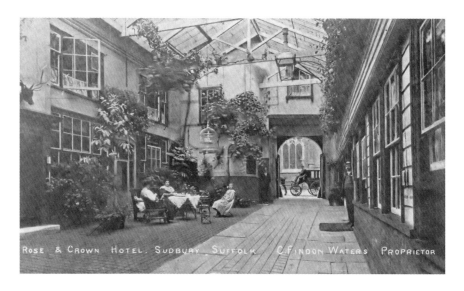

Rose & Crown, Postmarked 1907

In the Edwardian period, the proprietor of the Rose & Crown Hotel was C. Findon Waters; he is the man standing in the doorway. In March 1907, Mr Waters gave a talk and presentation to a new Sudbury club, the Eatanswill Club, entitled 'Is Sudbury "Eatanswill"'. Eatanswill was the fictional rotten borough depicted in Charles Dickens' The Pickwick Papers. Many (including the club) thought that Eatanswill was based on the borough of Sudbury. Dickens had been a reporter in Suffolk and Norfolk in the 1830s, so witnessed the 1834 parliamentary bi-election in the town. The Eatanswill Club argued that Dickens' pub, The Town Arms Inn, was the Rose & Crown, and therefore the headquarters of Dickens' Blues parliamentary party. The Rose & Crown Hotel was destroyed by a fire in 1922. The shop next to it, Winch, was also gutted by the fire. Winch was able to take advantage of the fire, and today, in the place of the Rose & Crown Hotel is the small department store Winch and Blatch.

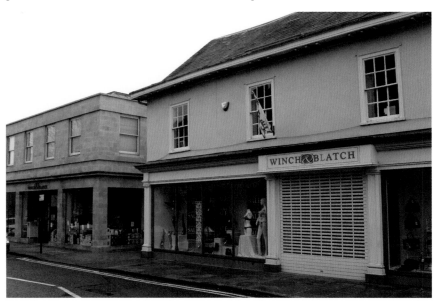

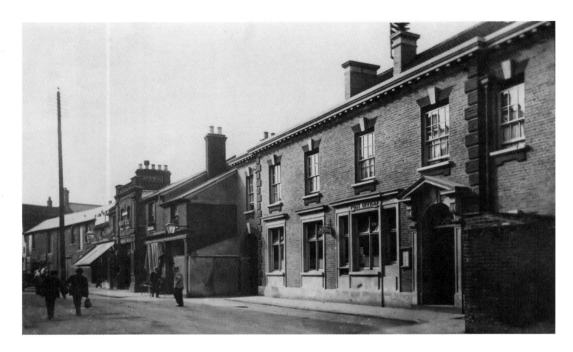

Post Office, Station Road, Postmarked 1913
During the Victorian and Edwardian period, Sudbury's post office was located on Market Hill. In 1911/1912, the post office moved to Station Road where it remained until it moved again to East Street in the 1970s. The old post office building is now the Kingdom Hall for the Sudbury branch of the Jehovah's Witnesses.

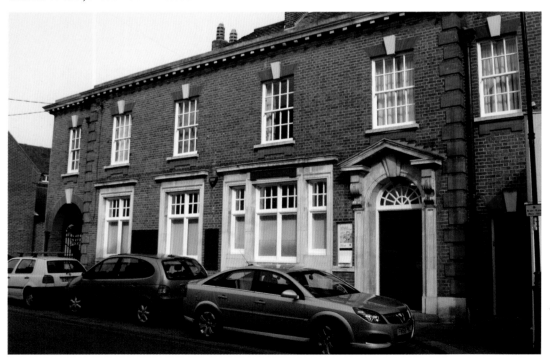

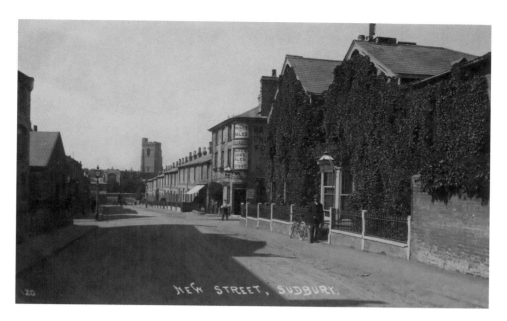

New Street, Postmarked 1912

The ivy-clad building in the right foreground of the postcard was Sudbury's Conservative Club. Purpose-built, it was opened during a grand ceremony on Friday 29 October 1886 by William Henry Smith MP (W. H. Smith II, of the newsagent fame), then the Secretary of State for War. The club was originally named The Working Men's Conservative Club and had 350 members with an annual subscription of £86 (according to one local newspaper, 'almost all [are] working men'). Newspaper reports are silent as to how a 'working man' afforded the subscription which was roughly one and half times the annual salary of a bank clerk, and just under three times the average annual salary for a labourer. In 2014, amongst falling membership, the club finally shut its doors, with the fate of its building currently unknown.

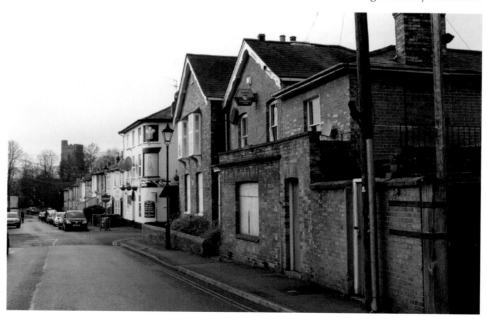

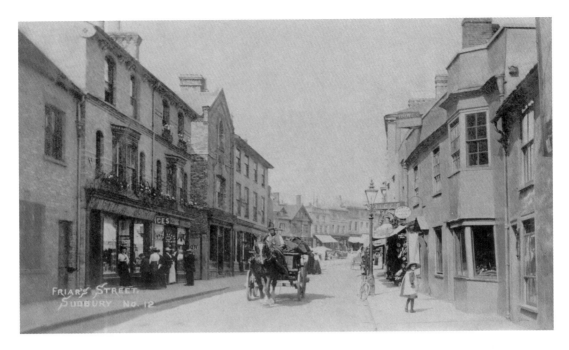

Friars Street (looking towards the Market), Postmarked 1908

The name of this Sudbury main thoroughfare reflects far back into the town's past and the existence of a Dominican Friary. A religious order, the Dominicans were founded by the Spanish priest, St Dominic (1170–1221); his priests became known as black friars. The precise date of the foundation of the first Dominican priory in Sudbury is unknown. The oldest surviving account of the order in the town is 1247 when the king, Henry III, gave them 6 marks in money. Throughout the Middle Ages, the priory and its friars were influential and well-respected by the townsfolk. Following Henry VIII's break with Rome in 1530s and the Dissolution of the Monastries, the priory closed in 1539.

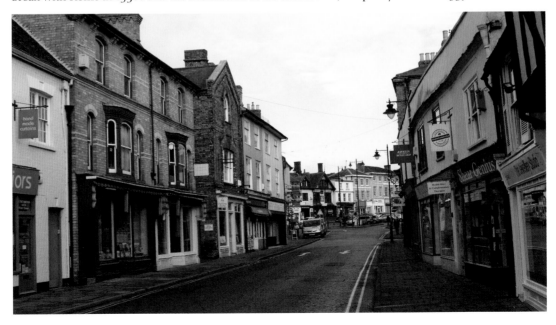

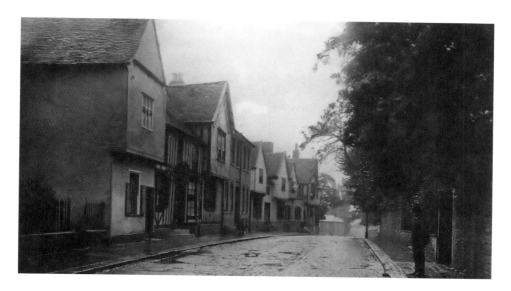

Stour Street and Salters Hall, *c.* **Early 1910s**

One of the finest range of buildings in Sudbury is The Chantry and Salters Hall within Stour Street, which were built in the middle of the fifteenth century, possibly for wealthy merchants. In the nineteenth century, the houses were in private ownership and throughout the Victorian era, local newspapers regularly reported field trips by the Bury and West Suffolk Archaeological Association. The Chantry and Salters Hall were one of the highlights of the association's Victorian Perambulations of Sudbury. In 1910, Salters Hall was the subject of much local gossip when the mayor of Sudbury, Mr W. J. Langdon, died while cleaning his guns at the Hall. In the latter part of the twentieth century, Salters Hall was the location of a preparatory school, which closed its doors in April 1995.

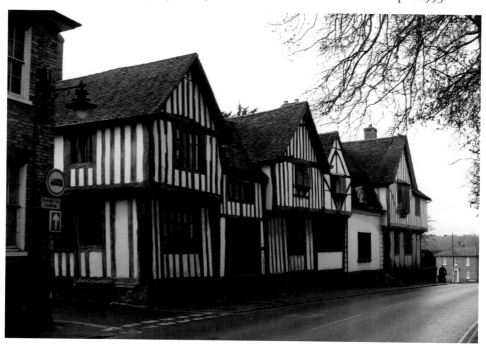

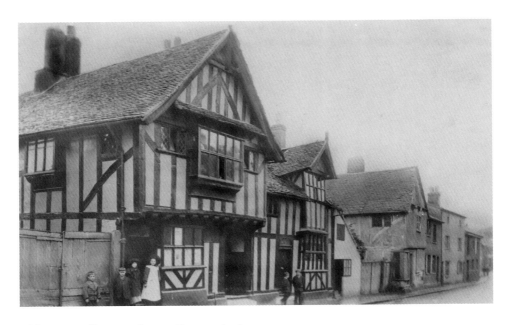

Old Moot Hall, Cross Street, Postmarked 1910

Originally built during the medieval period as a wealthy merchant's house, this building was either used as the hall of a prosperous medieval merchant's gild, or as a moot hall (town hall). During Mary I's reign (1553–58), a new moot hall was built immediately outside St Peter's Church on Market Hill. The new moot hall can be seen in the postcard which opens this chapter (an artistic impression of Market Hill in the 1800s). Sadly the moot hall in Market Hill was demolished during the 1830s/1840s as part of the town's alterations following the Sudbury Improvement Bill of the 1820s. Fortunately, the Old moot hall in Cross Street has remained and is now a house in private ownership.

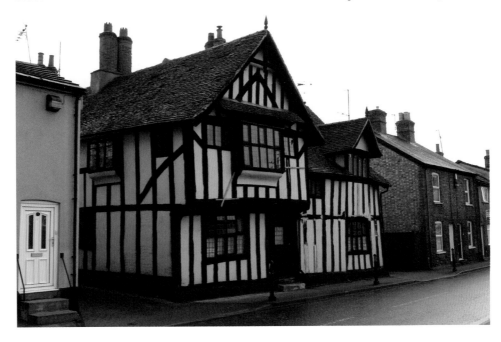

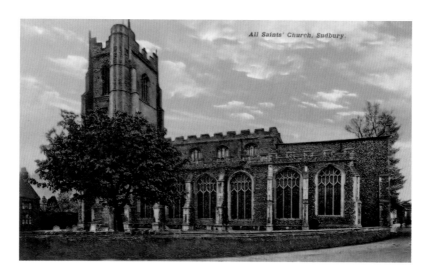

All Saints' Church, Sudbury.

All Saints, Church Street, Early 1900s

Sudbury has two parish churches: All Saints and St Gregory's. All Saints, in the south-west corner of the town, was built during the Norman era but had extensive alterations made in the fourteenth and fifteenth centuries. At some point during its early days, All Saints church purchased a chapel in the nearby Essex village of Ballingdon (now part of the town of Sudbury) to support its work. During the reign of Henry II (1154–89), both All Saints church and Ballingdon chapel were purchased by St Alban's Abbey, who owned them until Henry VIII dissolved the abbey in the 1530s. Two hundred years later and one of Thomas Gainsborough's most famous paintings, *Mr and Mrs Andrews*, contains a tiny perfectly executed representation of All Saints church in the centre of his landscape. Robert Andrews and Frances Mary Carter having married in All Saints church on 10 November 1748.

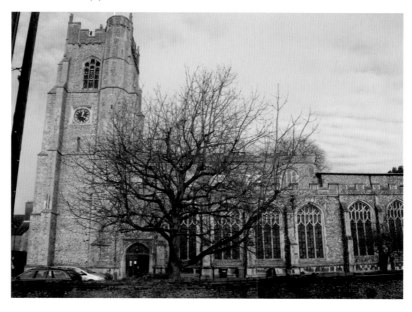

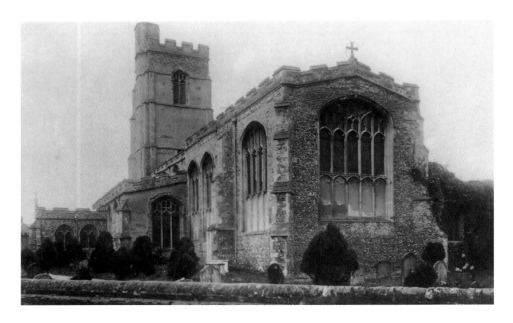

St Gregory's Church, Gregory Street, c. 1910s

One of Sudbury's famous men was Simon of Sudbury (c. 1316–81). Born in Sudbury, Simon had an illustrious career, and, in turn, became a chaplain to Pope Innocent VI, the Bishop of London, the Archbishop of Canterbury, and Lord Chancellor of England. After he became the Bishop of London, he purchased St Gregory's church in Sudbury from the nuns of Nuneaton in Warwickshire. After the purchase, Simon was heavily involved in a large project to rebuild the church. He also set up next to the church St Gregory's College (on the site where his father had once lived); a collegiate of secular canons and chaplains. He was the Archbishop of Canterbury from 1375 until he met a bloody end at the hands of rebel leaders during the Peasant's Revolt. During the revolt, he was dragged from his hiding place in the Tower of London and his head hacked off at Tower Hill. After his brutal murder in 1381, Simon's body was buried at Canterbury Cathedral, but his head was taken down from a pike on London Bridge (where the rebels had placed it) and taken back to St Gregory Church's in Sudbury. His head remains to this day inside a small wall-closet in St Gregory's. Inset: Next to the church, the remains of the gate to St Gregory's College.

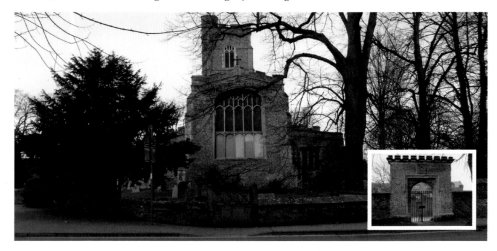

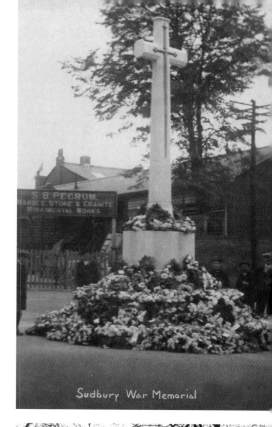

Sudbury War Memorial

Sudbury War Memorial, 1921

The original location of the war memorial was at the top of North Street, but it was moved to its current location by St Gregory's church in the mid-1960s. The memorial commemorates over 220 deaths from the First World War. This includes five civilians killed by bombs dropped from a German Navy Zeppelin on 31 March 1916, sixty names from the Second World War and one name from the Northern Ireland conflict. The memorial was built of Portland stone to the design of Sir Reginald Blomfield, and unveiled on Sunday 2 October 1921.

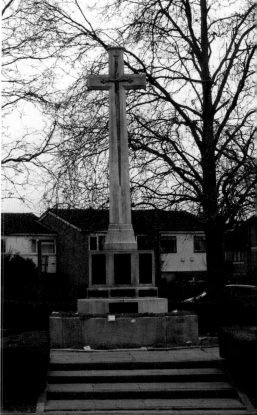

Catholic Church, The Croft, Postmarked 1903

The first mass to be held publically in Sudbury since the reign of Catholic Queen Mary (reigned 1553–58) was celebrated in a private house in Church Street in November 1876. The front room had been converted into a Catholic chapel and named The Church of Our Lady and St John the Evangelist. The church moved to The Croft in the 1880s where two Victorian cottages were purchased. One cottage was eventually knocked down to make way for a new Catholic church, and the other became the presbytery (this is the building to the current church's immediate left). In 1893, the new church was built, financed by subscription. The architect was Leonard Stokes of London, and the builders were the local firm of George Grimwood and Sons. The foundation stone was laid by the Bishop of Northampton on Tuesday 27 June 1893, and the new Catholic Church consecrated by the sprinkling of holy water on the foundations. Prior to the English Reformation of the sixteenth century, St Gregory's church was home to the Shrine of Our Lady of Sudbury. The Shrine was hidden during the Reformation and restored in the 1930s. Now housed in the Catholic Church, in 1946 British newsreels captured the moving ceremony of Bringing Home Our Lady at Sundown when Our Lady was carried shoulder-high throughout the streets of Sudbury and brought back to her home in the Catholic Church in The Croft.

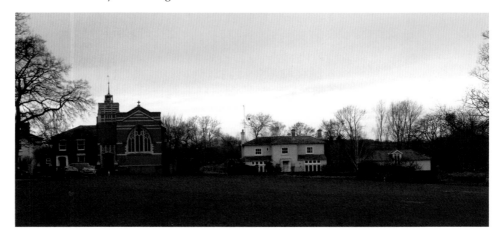

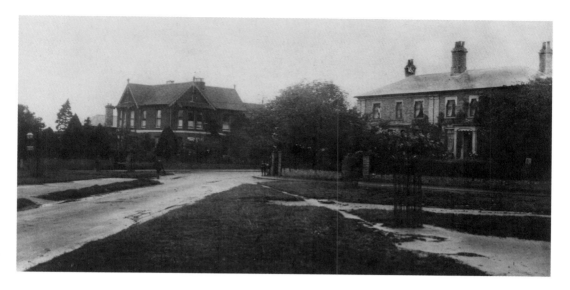

The Croft, Postmarked 1910

The building on the left is Crofton House which became a children's home in the 1920s and closed in 1962. During the Second World War it was a home for children evacuated from London. Prior to its use as a home, Crofton House had been a private residence for the wealthier members of Victorian Sudbury. At the end of the nineteenth century, it was owned by Mr John Cox Lynch, the town's surgeon and one of St Gregory's churchwardens. In 1886, Mr Lynch provided much local gossip and debate when he severely beat a 5-year-old boy he had caught throwing stones and breaking windows in the church. Following a series of local court cases, Lynch was fined 5s for committing assault on the boy.

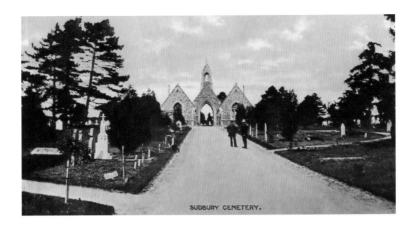

SUDBURY CEMETERY.

Sudbury Cemetery, Newton Road, Early 1900s

By the middle of the nineteenth century, burials in parish churchyards (most of which were medieval in origin) could not cope with the country's expanding population. Across England, burial boards were set up in many towns to alleviate this problem by building purpose-built cemeteries. Sudbury Burial Board was set up in 1854 but there was much heated controversy and discussion by board members about which parishes it should include. By February 1858, matters had reached the courts when a *mandamus* writ was brought against Sudbury Burial Board to force them to raise the money required (via rates or a loan) to build the town's cemetery. Eventually, in June 1858 the Court of the Queen's Bench ordered Sudbury Burial Board to perform their duties and build the town's cemetery. However, this ruling still did not make the Board act: local newspapers reported that after the court's ruling, there was a large meeting in the town hall at which the vicar of St Gregory argued that there was still enough room in St Gregory's churchyard. It was only when the Home Secretary, Spencer Horatio Walpole, stepped in to forcefully state that after 1 January 1860 no new burials could take place in St Gregory's that Sudbury's Burial Board finally conceded and agreed to perform its duties. At this point, after years of delay, events moved very swiftly. Before the cemetery and Anglican chapels had been built, the first burial took place in the new cemetery on the Saturday 15 January 1859 in the Dissenters' section, with over 500 people in attendance. On 31 May 1859, the Bishop of Ely officiated at the consecration service of the cemetery. The Victorian parochial and local government dispute about Sudbury's cemetery finally resolved.

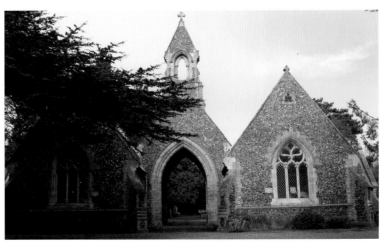

Sudbury & the River Stour

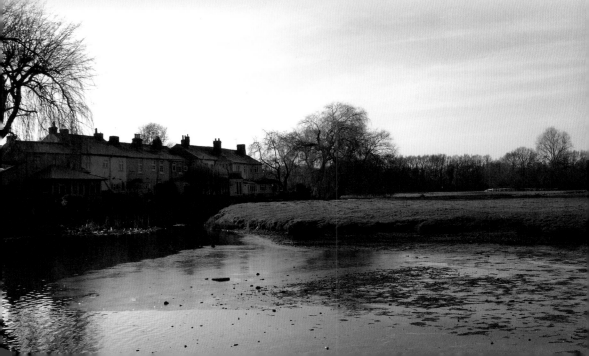

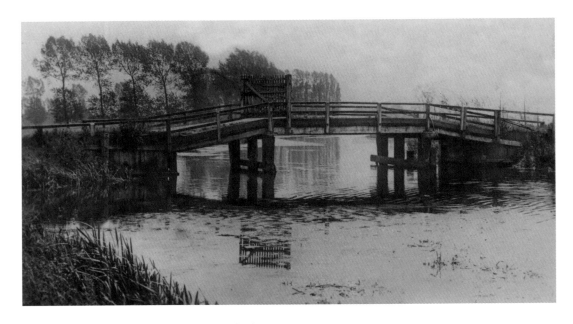

Ladies Bridge, Friars Meadow, Postmarked 1921

Downstream from Friars Meadow is Ladies Bridge which links Lady's Island to the River Stour. During the Victorian and Edwardian period, this part of the river appeared to have been used as a community and recreation area for the townsfolk of Sudbury. One such event took place in February 1858 when many hundreds of men, women and children flocked to the bridge to watch a four geese pull a wash-tub containing a clown from Powell's circus through the river from the bridge to the quay. Other events by the bridge included an open air religious service by a Baptist minister to 1,000 people in 1860, and in August 1868 a large bank holiday parade. On a cold winter's morning in 2015, the bridge hides its colourful past deep within its ancient timbers.

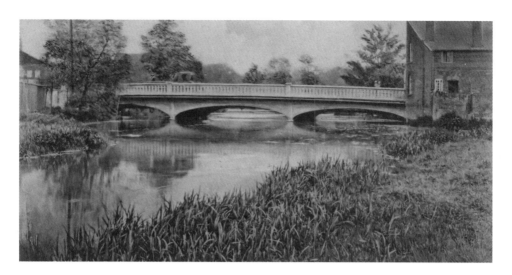

Ballingdon Bridge, After 1910

On the south-west side of the town is the bridge over the River Stour which connects the village of Ballingdon (originally in Essex) to the town of Sudbury. The first evidence of a wooden bridge was at the start of the thirteenth century when tolls were collected on behalf of the Countess of Clare. But it is likely that a bridge existed here further back in time. From 1549 until 1888, Justices of the Peace from the two counties the bridge spanned (Essex and Suffolk) ordered its repairs, with each part of the bridge regularly requiring maintenance by its responsible county. In 1805, the entire bridge was pulled down and new wooden one was built with each county financing their own section. This bridge lasted until 1910, when it was replaced by a reinforced concrete one. This bridge too served its time after an increasing amount of traffic daily streamed through Sudbury. In 2002/03, a new bridge was built using aluminium in its construction. While this, the most recent bridge was being built, archaeologists from Suffolk County Council examined the bridge's timber piles visible in the water at low water. From this, they ascertained that two of the forty-nine piles examined could be precisely dated: one was from a tree felled in 1595 and the other felled in the winter of 1599. Other piles were dated to *c.* 1660, *c.* 1760 and *c.* 1800. Firm scientific evidence to the extent of the maintenance required to the wooden structure.

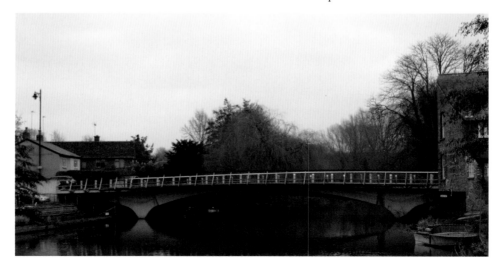

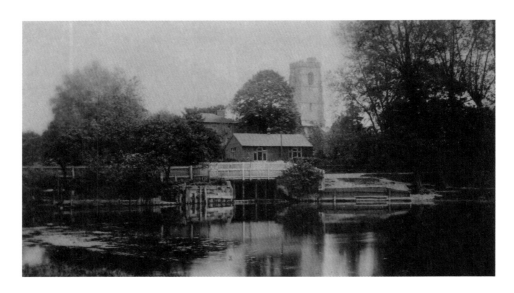

St Gregory's from Freeman's Common, 1910s

One of Suffolk's hidden beauty spots is that of Sudbury's Common Lands and water meadows, through which rambles the picturesque River Stour. The Common Lands consist of North Meadow Common (thirty-nine acres), Kings Marsh (eighteen acres), Freeman's Great Common and Freeman's Little Common (combined together fourteen acres), and Little Fullingpit Meadow (seventeen acres). The rights to graze cattle during the summer months by non-landowning townsfolk of Sudbury first happened in the late twelfth century when Amicia de Clare granted rights for the land known as Kingsmere (now Kings Marsh) and Portmanscroft (now Freeman's Little Common and Freeman's Great Common). Today, Sudbury Common Lands is a charity (founded in 1897) managed by trustees with uniformed volunteer rangers.

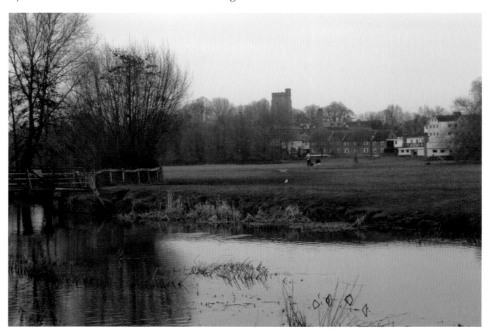

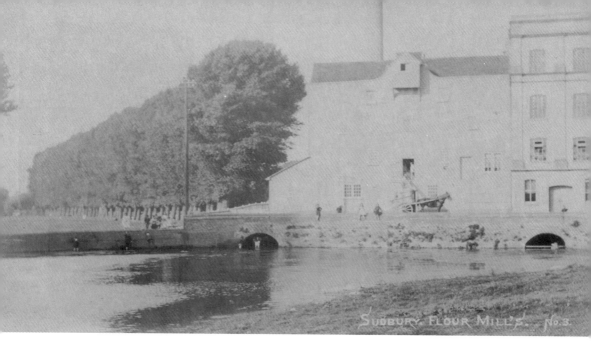

Sudbury Flour Mill, Freemans Great Common, Postmarked 1907
William the Conqueror's great land tax survey of 1086, Domesday, lists Sudbury as having a mill but does not specify its exact location. However, it is likely to be have been at the same location as the buildings in these images. Known as Clover's Mill in the nineteenth century (after its owner Isaac Ernest Clover), it is now the Mill Hotel and a very pleasant place to pass time after walking through Sudbury's scenic common lands. The current mill building is believed to have been built in the seventeenth and eighteenth centuries, with the east wing built in the nineteenth century.

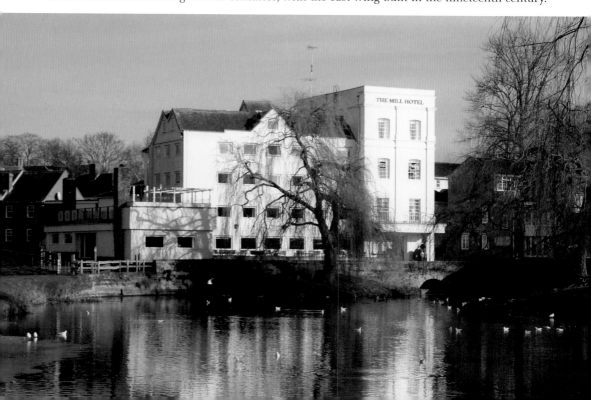

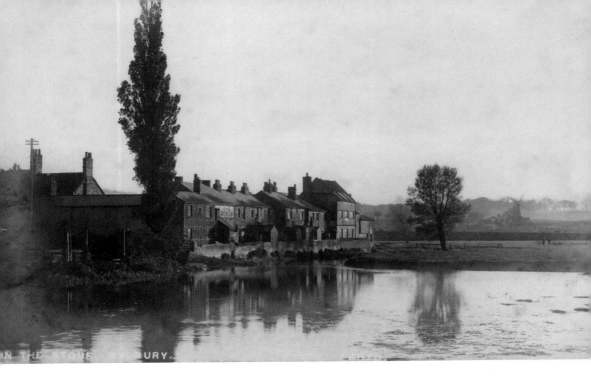

On the Stour, Mill Stream, Early 1900s

Directly outside the Mill Hotel is one of the most beautiful parts of the River Stour in Sudbury: Freemen's Great Common. This view is with the Hotel directly behind the photographer looking back towards Ballingdon. In the distance of the Edwardian postcard is the very faint image of Ballingdon's windmill, its sails in partial flight. Now sail-less, the body of the windmill still exists but is no longer visible with the naked eye from the mill stream. Today in 2015, Ballingdon's windmill has a new use as an artists' retreat and destination for holiday-makers escaping the rat-race.

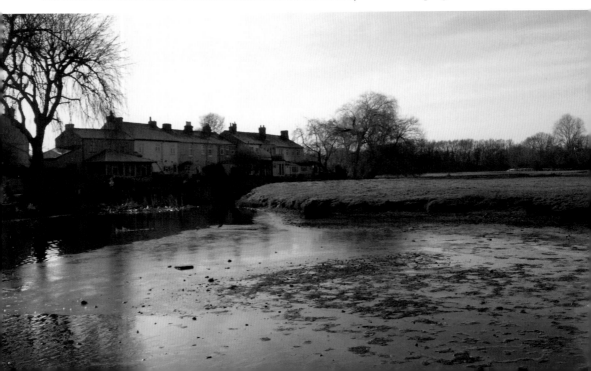

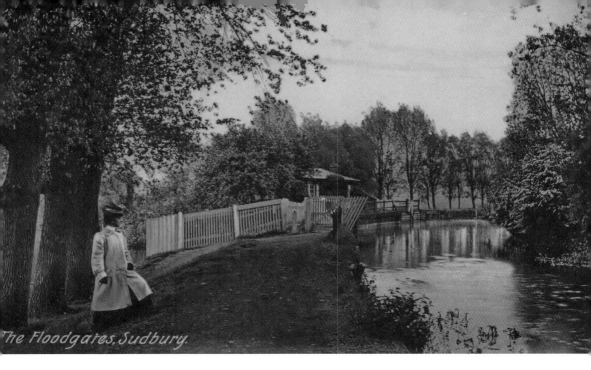

The Floodgates, Sudbury.

The Floodgates (facing towards Great Fullingpit Meadow) *c.* **Early 1900s**
An Edwardian lady stands by the entrance to Sudbury's floodgates and sluice, in the middle distance is the floodgate keeper's cottage. An employee of the flour mill, the floodgate keeper's job was to open and close the sluices thereby controlling the water flowing towards the mill (now the Mill Hotel). In the modern photograph, the floodgate keeper's cottage was just past the metal railings on the left; nothing now remains of the cottage but a small area of brickwork and a seating spot indicating the rough location of his cottage. The current safety railings hides the modern-day beauty of the area.

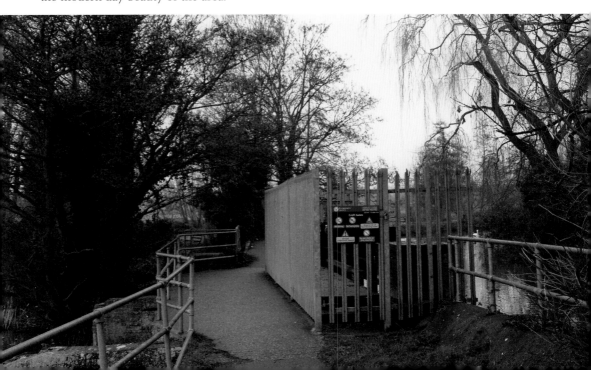

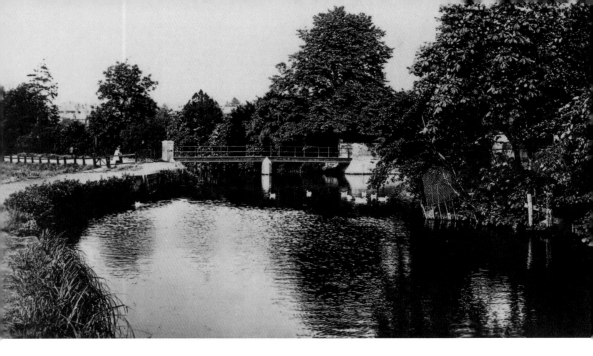

Croft Bridge, *c.* 1910s

The bridge over the River Stour connects The Croft to Fullingpit Meadows. The Meadows were given to Sudbury Corporation by John Knight in the 1730s, for the use of the freemen of Sudbury to graze their cattle. Croft Bridge was originally built in the 1790s so that the freeman could drive their cattle to Fullingpit Meadows. Throughout the nineteenth century, local newspapers reported repairs to the bridge, and the occasional drownings nearby. Just beyond Croft Bridge is the Old Bathing Place.

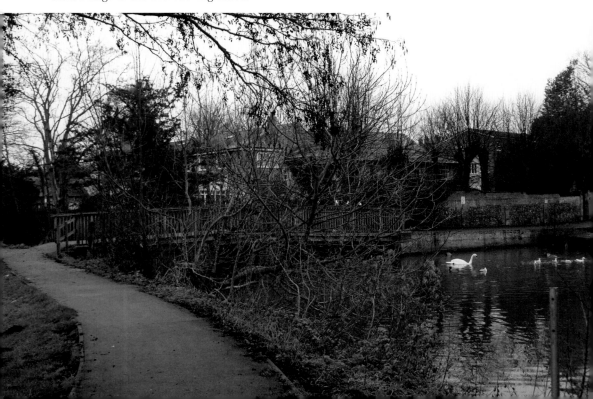

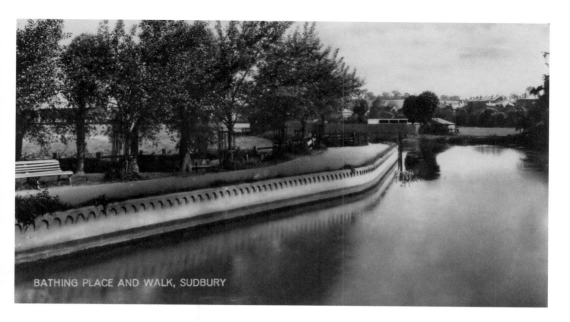

BATHING PLACE AND WALK, SUDBURY

Bathing Place and Walk, Fullingpit Meadow, *c.* 1910s

On 27 June 1894, the mayor and mayoress of Sudbury opened the newly built Bathing Place in Fullingpit Meadow. The Place was built at a cost of £400 and consisted of a 'good sized and accessible public bathing-place with concrete bottom, with dressing compartments, and generally with excellent and substantial accommodation'. The opening of a bathing-place was not pleasing to all residents. Shortly after its opening, on three separate occasions a retired baker, Mr W. Fenton, whose house was nearby, ripped through the canvass which was used to hide bathers from public view. The dispute was resolved by September 1894 following threats of legal action by the council. The Bathing Place continued to popular throughout its lifetime, until an outbreak of diphtheria in the late 1930s forced its closure. Today, the outline of the pond still remains, with its concrete steps down into the water, but its buildings and changing rooms long gone.

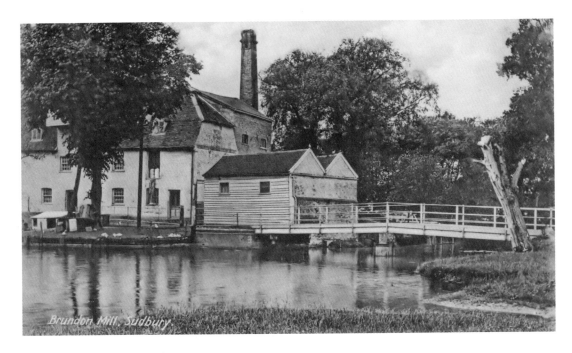

Brundon Mill, *c.* Early 1900s

The tiny hamlet of Brundon on the west bank of the Stour is on the very edge of Sudbury town. Like its slightly larger neighbour, Ballingdon, the village was once within the county of Essex. Prior to the nineteenth century, the two villages were known as Ballingdon-cum-Brundon, and in Essex's Hickford Hundred. Both villages became part of the parish of Sudbury in the 1830s, thus are now in the district of Babergh and the county of Suffolk. Today Brundon Mill is extremely picturesque with a group of mill cottages close-by and a large mill pond containing a whiteness of swans.

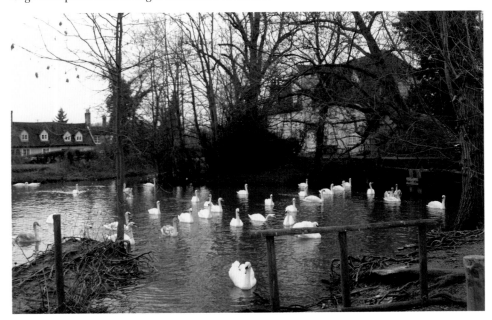

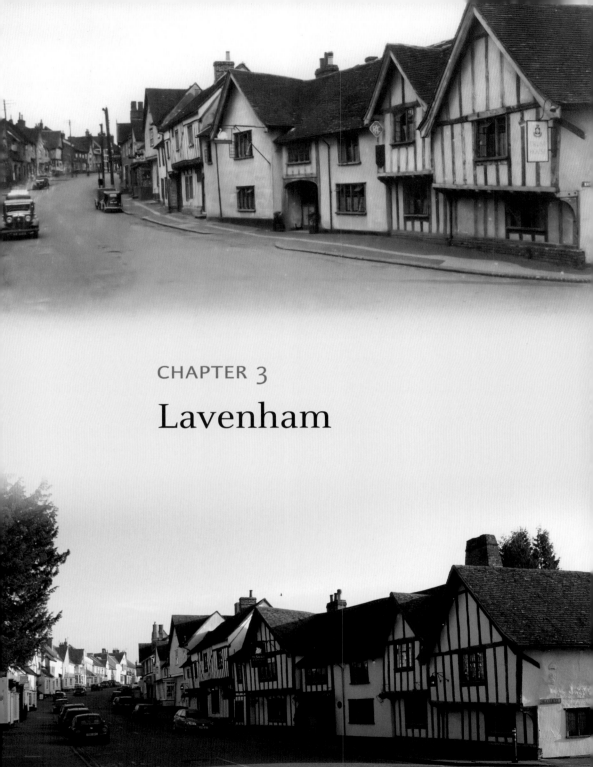

CHAPTER 3
Lavenham

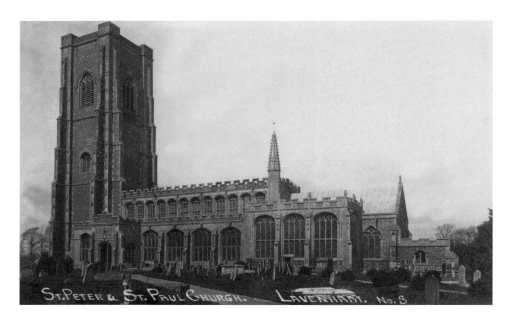

St Peter and St Paul's Church, Postmarked 1916

The church of St Peter and St Paul is one of the most handsome and famous parish churches within England. With its tower rising up into the sky at over 140 feet (allegedly the tallest church tower in England), it can be seen for miles around in neighbouring Suffolk villages and hamlets. Known as one of Suffolk's mighty wool churches, it was financed on the incredible wealth made by local families connected to the medieval Lavenham wool trade, along with money from John de Vere, the 13th Earl of Oxford (1442–1513). While there was an earlier Saxon and, later a Norman church on the site, the majority of church seen today was built from the 1300s onwards, with the main construction taking place between 1485 to 1525.

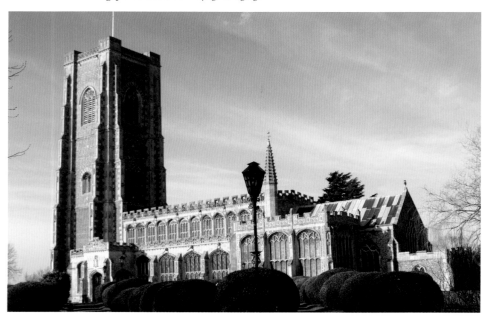

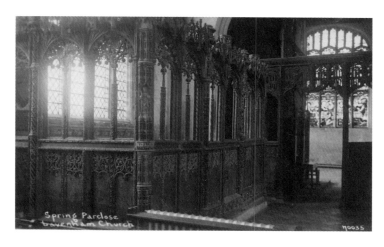

Spring Parclose, inside St Peter and St Paul's Church, c. 1920s

On the left (north) side of the church's interior is the Spring parclose, a structure (normally of wood) enclosing a small private side chapel within a church. The Spring parclose was commissioned by Alice Spring and made by Flemish woodcarvers to contain the tomb of her husband, Thomas Spring III (1456–1523). He became known as the Wealthy Clothier, and his wealth included extensive lands in Suffolk, Cambridge, Norfolk and Essex. He is thought to have been the richest man in England outside the nobility. By the time Henry VII's death (reigned 1485–1509), the first Tudor monarch had become unpopular because of his arbitrary taxation and injustices. In an attempt to give the Tudors a fresh start, his son, then very young and popular Henry VIII, issued a general pardon to named people throughout England to allow them to purge themselves of any crimes they may have committed under his father's reign. The text was printed in London shortly after Henry VIII ascended his throne, and then posted up throughout the marketplaces of England. No doubt Lavenham's market had a copy displayed in a prominent position. Spring, who had paid a heavy fine for smuggling into England goods used for his business during Henry VII's reign and had been pardoned by the old king in 1508 for various misdemeanours, was one of the many people who was pardoned by Henry VIII. No one could pursue him for any of his dishonest business dealings carried out during the reign of Henry VII. He continued to prosper during the reign of Henry VIII and died an extremely wealthy man.

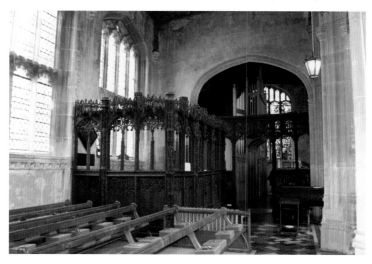

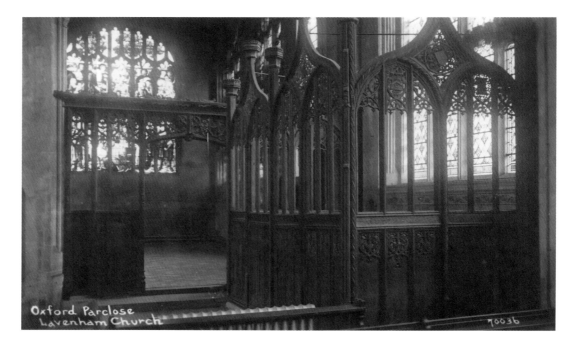

Oxford Parclose
Lavenham Church

70036

Oxford Parclose inside St Peter and St Paul's Church, *c.* 1910s

Also known as the Spourne parclose, is this ornate wooden structure on the right (south) side of the church. It was possibly built as a chantry chapel for the wealthy clothier Thomas Spourne, whose family's coat of arms is within the screen. Spourne is listed in Henry VIII's Lay Subsidy Returns of 1524 (a tax levied to pay for Henry's wars with France) as one of the richest men in Lavenham. The parclose now contains the tomb of John Ponder (died 1520) which was originally in the churchyard but moved into the parclose in 1908. The evidence of carved graffiti throughout the inside of the parclose shows that at some stage this must have been a private chapel for use during church service by members of a wealthy family. Inset: Graffiti on the inside of the parclose. No doubt carved to perfection by bored boys during church services.

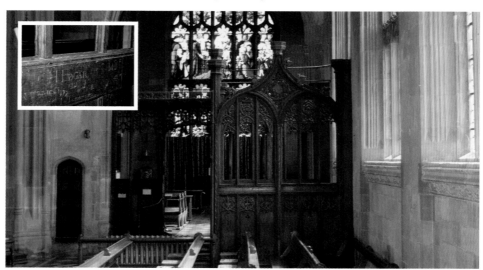

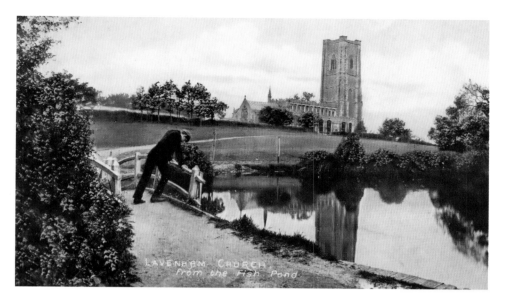

Lavenham Church from Lavenham Hall's Bridge and Fish Pond, c. 1900s

In 1086, twenty years after William the Conqueror successfully invaded England, his great Domesday tax survey recorded that the Lord of the manor of Lavenham and its Tenant-in-Chief was Aubrey de Vere, one of William's dominant Norman barons. This is one of the first documentary evidences of the powerful de Veres within Lavenham, and their meteoric rise to great wealth and fortunes. The original manor house inhabited by the de Veres no longer exists. The current Lavenham Hall was built in the sixteenth and seventeenth centuries but was considerably renovated from the eighteenth century onwards. Today, the Edwardian view from the Hall's fishpond over to the church is totally obscured all year round by brambles, hedges, trees and wild plants. In the modern photograph, the church is towards the left side (off-image) and Lavenham Hall is just peeking through the bars of the bridge, past the fishpond.

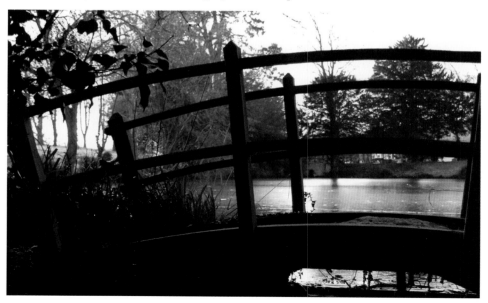

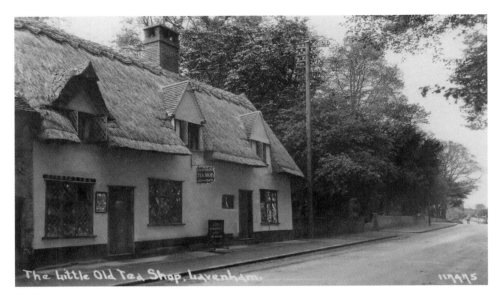

The Little Old Tea Shop, Church Street, Lavenham, *c.* 1920s

The Little Old Tea Shop, Church Street, Lavenham, *c.* 1920s

Immediately opposite St Peter and St Paul's church are two cottages: Glebe Cottage (the flint-cobbled cottage on the left) and Church Cottage (the thatched cottage on the right). As can be seen by the number of doorways, each cottage once contained two separate dwelling-places. Now known as Church Street, this area of Lavenham was originally part of the High Street, then renamed as Church End, and finally given its current-day name of Church Street.

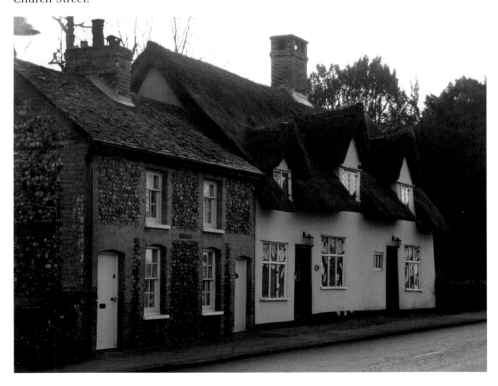

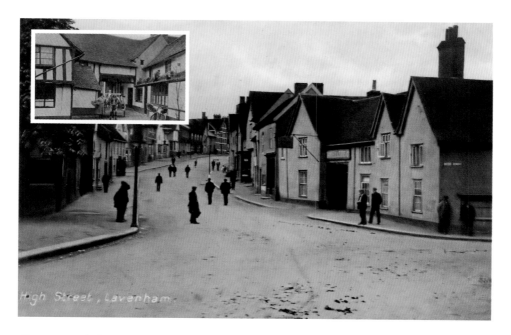

The Swan, High Street, Early 1900s

Lavenham's iconic hotel, The Swan, was originally built in the late fourteenth century. During the stagecoach era, the inn had a middle entrance with a high roof to allow tall stagecoaches into the coach yard at the back. The inn was the location of two stagecoach routes, and the place where the horses were changed over. By the 1920s, as can be seen in the postcard which opens this chapter, the stagecoach entrance had been lowered, with a room built over the top of the archway. During the Second World War, the US Army Air Force 487th Bombardment Group were based at nearby Lavenham Airfield. Many airmen used The Swan during their leisure time, and today, one of The Swan's most interesting rooms is the Airmen's Bar with its memorabilia and graffiti from their time in England. Inset: (1) The old coaching yard, back of Swan, 1930s; (2) Pargetting on the side of the Swan Inn.

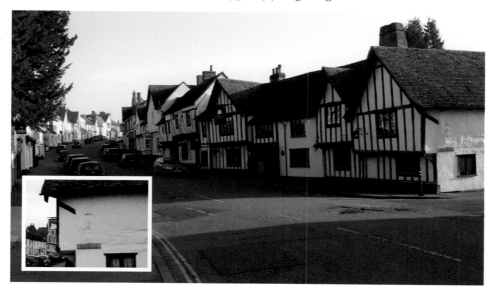

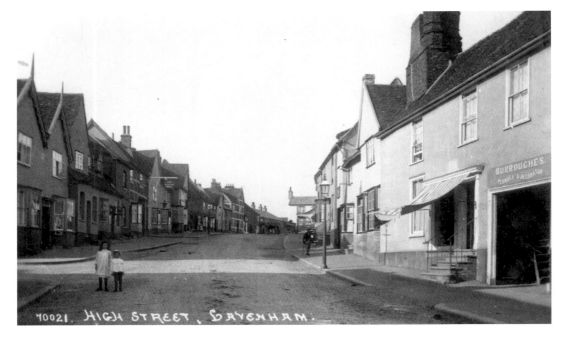

High Street, Early 1920s

Lavenham in the early part of the twentieth century appeared to have been a village with few traffic problems. Its Edwardian postcards are full of people with their horses and carts, but little congestion on the roads. Sadly, that is not the case today: with no means to bypass the centre, Lavenham is full of lorries and cars, competing with large agricultural vehicles. On an average weekday, navigating this narrow High Street is an absolute nightmare. Sometimes this ancient village is brought to a total halt if two large vehicles happen to make the mistake of meeting each other in the middle of the High Street and try to pass each other. It is an accident waiting to happen, and would be a great tragedy if a building in this, the most beautiful of English medieval villages, becomes a victim to being struck by an articulated lorry.

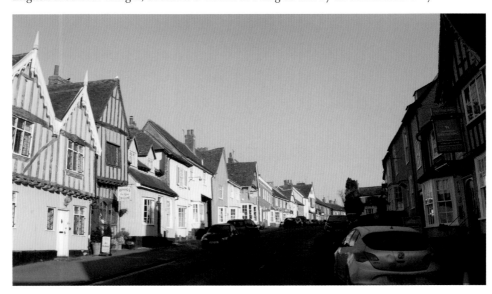

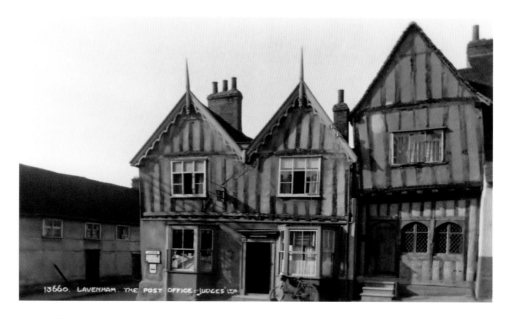

Post Office and Crooked House, High Street, *c.* 1920s

Lavenham's crooked house, with its gravity-defying bend to the upper floor, is one of Lavenham's most photographed buildings. Next to it is (or rather, was) the post office and shop, now a private house. At some point in the twentieth century, the post office moved a few shops further up the high street. When Lavenham's postmaster and postmistress retired in 2012, it looked as though the post office would be lost to the village. Fortunately, after a fight, the post office was retained and is now within Lavenham Pharmacy, a few doors down from its original 1920s location.

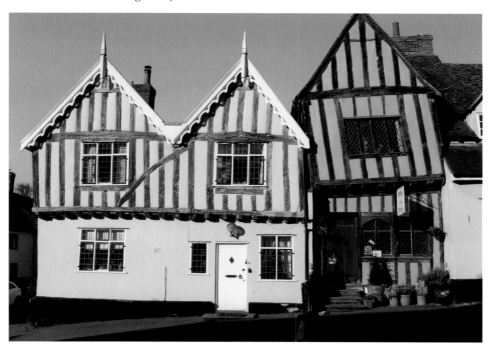

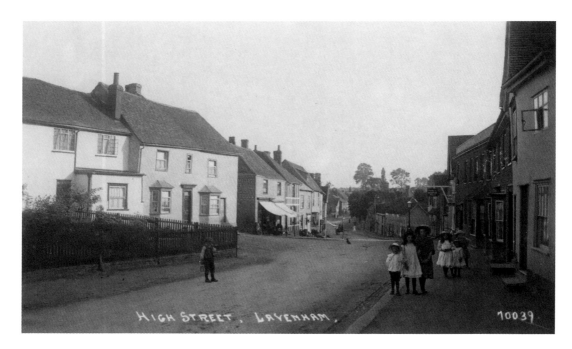

High Street (facing south), Early 1900s

On the right of the Edwardian view is The Black Lion Hotel, now Timbers Antiques and Collectors Centre, where many a happy hour can be lost browsing in the Centre's cavernous rooms full of curios, collector's items, antiques and local history books. In the centre of the picture is the narrow Market Lane which leads to the glorious market place and Guildhall. Just before Market Lane is the fifteenth century building, now known as Cordwainers, but was previously The Bell Inn: its handsome medieval timbers revealed sometime after the date of the Edwardian postcard.

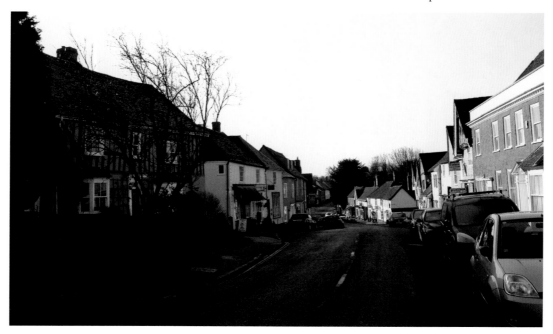

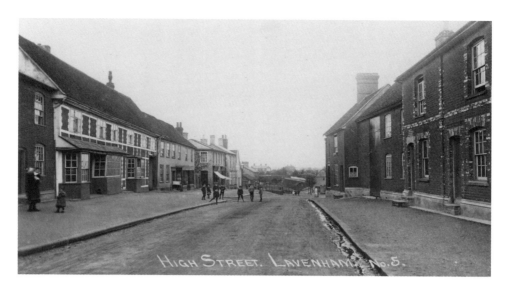

High Street (facing north), Early 1900s

At the top part of the High Street, many of the red brick Georgian and Victorian buildings have dating-stones predominately with the names of two local businesses: Thomas Turner and W. W. Roper & Sons. The long building in the left foreground was a public house until the early nineteenth century, but, according to F. Lingard Ranson, became the headquarters of Thomas Turner's woolstapler business. Here Turner ran his successful business of buying, sorting, grading and onward selling of wool. From the dating stones on many small workman's cottages throughout this area, it would appear that Thomas Turner (1784–1864) was an active employer from the 1820s until the 1860s. William Whittingham Roper (1820–90) opened his first Lavenham horse hair factory in Water Street in the mid-nineteenth century. In 1882, he expanded his business to the high street taking over many of Thomas Turner's buildings. According to a local newspaper, his factories produced 'nothing but the best double hand made hair seating', along with 'well cured curled hair, hair cloth, hair sieve bottoms, crinoline cloths, all brushmaker's drafts in hair and fibre, and cocoa-nut fibre mats and matting'. Inset: A row of Thomas Turner's workers cottages built in 1856.

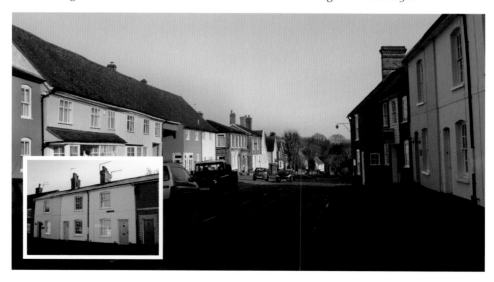

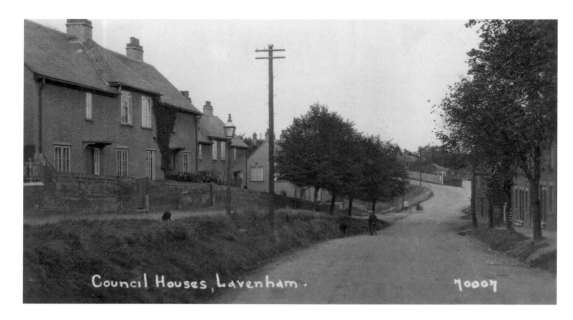

Council Houses, Lavenham. 70007

Council houses, High Street, Postmarked 1927

At first glance, this view photographed from the far north of the High Street has changed little between the 1920s and 2015. Then and now: the council houses are on the left and W. W. Roper & Sons red-brick terrace of workers' cottages built in 1909 on the right. The major difference is at the far end of the photographs and fading into the distance. In the 1920s, the buildings are those of Lavenham's railway station with its platforms and buildings. In 2015 the view is of The Halt, a brand new development of luxury houses on the corner of Preston Road. Opened in 1865 as a branch line between Long Melford and Bury St Edmunds, Lavenham station closed to passengers in 1961 and to freight in 1965. The original station buildings remained until the 1980s, when they were demolished to make room for industrial units, which, in turn were demolished in 2012 to make room for The Halt.

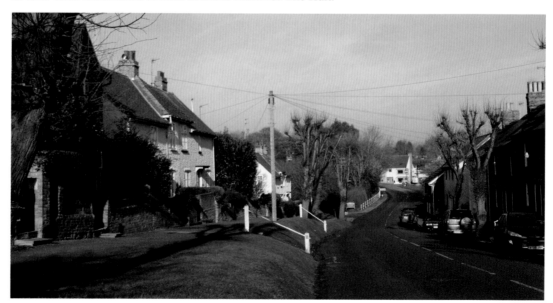

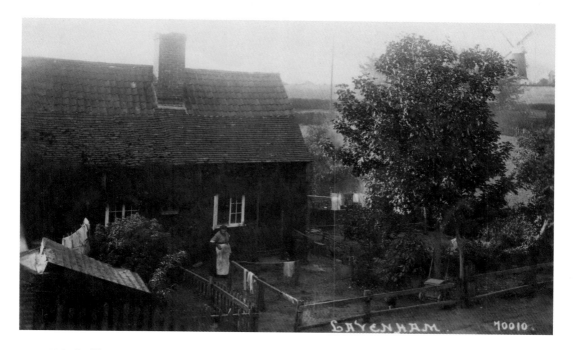

Windmill, Bury Road, Before 1921

It is wash-day in Lavenham, sometime before 1921. The windmill in the top right corner of the postcard was in Bury Road on the way out of Lavenham, past the railway station. The top section of the windmill was demolished in 1921 by its then owner John W. Baker. Today only the bottom part of the windmill's post remains within the grounds of Mill House. Without its post and sails, the remains of the mill are only visible during the winter months from nearby Dyehouse Field, when the vegetation is not at its summer thickness.

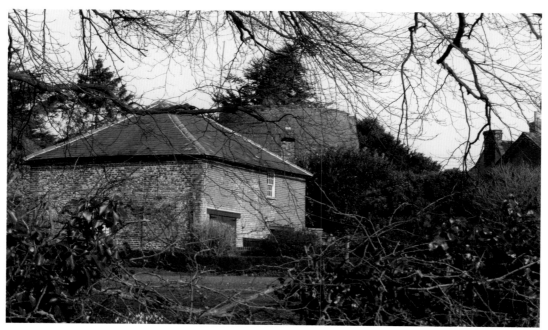

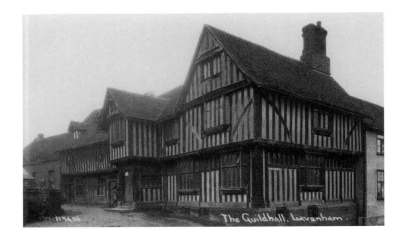

Guildhall of Corpus Christi, Market Lane, *c.* 1910s

The jewel in Lavenham's glittering crown is undoubtedly the Guildhall of the Corpus Christi. The Brotherhood of the Guild of Corpus Christi built their Guildhall in 1529, and it was one of four guildhalls within the village. It became the centre for Lavenham's trade in the cloth and wool business. However, by 1596, it would appear that the guild had disappeared as the Guildhall belonged to the parish and was possibly used as a village hall. Since the late sixteenth century, it has had many different uses. From at least 1689 until 1784, it was Lavenham's bridewell (prison) and afterwards was the parish's workhouse (pre the Poor Law Amendment Act of 1834), then an almshouse, and finally a store for wool. Eventually, in 1887 it was purchased by Sir William Cuthbert Quilter, 1st Baronet (1841–1911) who was the Member of Parliament for Sudbury from 1885 until 1906. After his death, the Guildhall passed to his son Sir William Eley Cuthbert Quilter, 2nd Baronet (1873–1952). He restored the Guildhall at great cost to himself as previously it was nearly derelict. During the Second World War, the Guildhall was used by evacuees from London. After the Second World War, Quilter gave the Guildhall to the Lavenham Preservation Society. In 1951, the Society raised an endowment of £4,000, which then enabled them to give the Guildhall to the National Trust, who has assured its future as one of the most impressive and important Tudor buildings within England. Inset: Sir William Eley Cuthbert Quilter at the time of the 1910 General Election.

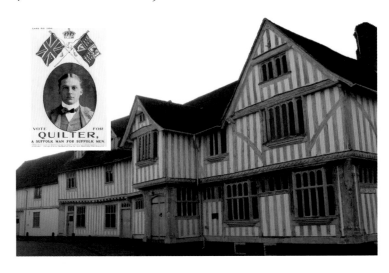

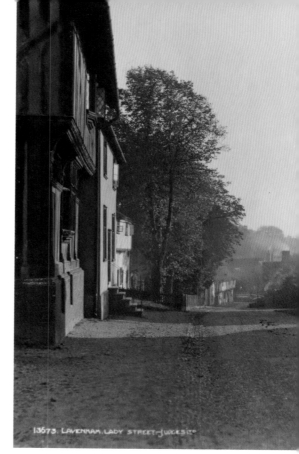

Right Corner of the Guildhall, on Lady Street (facing towards Water Street), Early 1930s

Running from the right side of the Guildhall of Corpus Christi down to Water Street is Lady Street, named after the Guildhall of Our Lady at the bottom of the road. At the time of the founding of the Guildhall of Corpus Christi, this street had also been known as Master John's Street and Baber Street. On the far right corner of the Guildhall is a carved effigy of John de Vere, the 15th Earl of Oxford (c. 1480s–1540). John de Vere was the patron and founder of the Guildhall of Corpus Christi. The presence of the de Veres are felt throughout many of the historic buildings in Lavenham, although their seat was at nearby Headingham Castle. Inset: Beautifully carved figure of John de Vere.

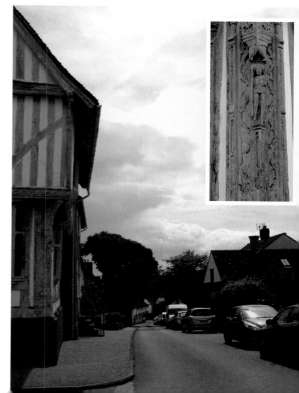

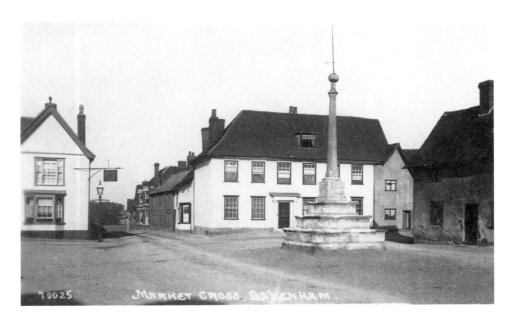

Market Place, *c.* 1910s

Lavenham was first granted a charter for its market in 1257, and since that time, the Market Place has been a busy bustling area of the village. But now, sadly, it is used more as a car park then a thriving market. In the centre background of the photographs is The Great House which was built by the wealthy Causton family in the fifteenth century, with its Georgian façade added to the building in the eighteenth century. Today it is a restaurant and hotel. In the foreground is Lavenham's market cross, which was built according to the terms of William Jacob's will of 1501. On the right edge of the image is the Toll Cottage – an ancient building where the market traders once paid their dues but is now an estate agent's office. Inset: Plaque in the Market Place commemorating the 750th anniversary of Lavenham's market charter.

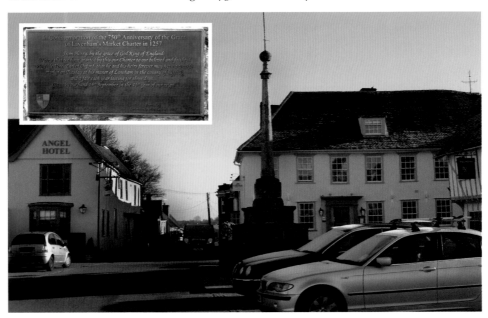

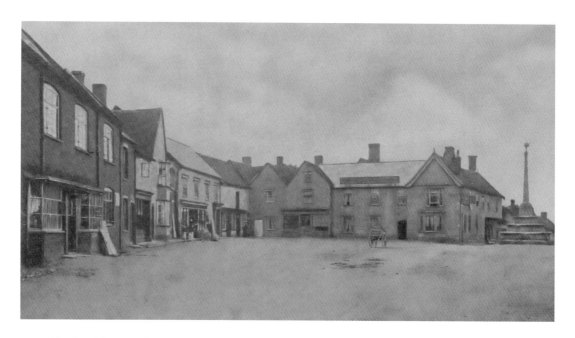

Market Place, Early 1900s

The building to the right is the Angel Inn pub and hotel. Built in the fifteenth century, by 1527 it was a private house owned by Thomas Sexten who bequeathed it to his son, Robert, on his death in 1529. The Sexten family were wealthy cloth merchants of the village and Thomas's grandfather, Aleyn, left £40 for the church's steeple on his death in 1487. Aleyn's wife, Joan left £10 to the church on her death in 1502. In modern times, for a short period of time The Angel was controversially owned by celebrity chief, Marco Pierre White.

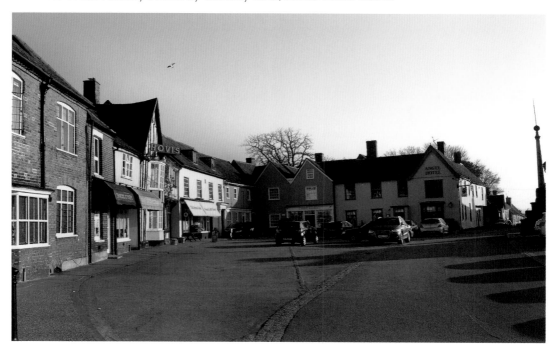

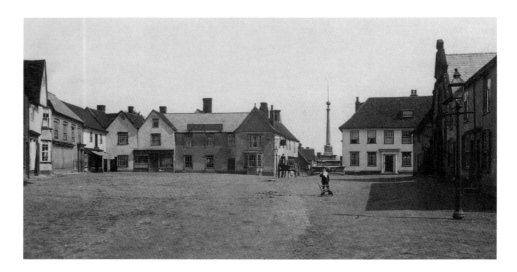

Market Place, *c.* 1910s

The Edwardian image of Market Place shows (on the far right side) part of the British School which was built in 1861 and demolished in 1964. Next to the British School and directly in front of the Guildhall were three cottages made out of lump clay: these were condemned and demolished in 1938. These cottages (along with two others which still exist) were originally founded from the butchers' stalls in the market. Thus, the road immediately outside the Guildhall was once known as The Butchery. The site of these buildings is now a pleasant area dedicated to the commemoration of Lavenham's war dead, along with the 487th USA Bombardment Group who were stationed at Lavenham Air Base in 1944–45. This area is one of the pleasantest places in Lavenham to sit and pass the time catching the sun, which always seems to shine on this part of the village, whatever the season. Inset: Plaque commemorating 487th USA Bombardment Group.

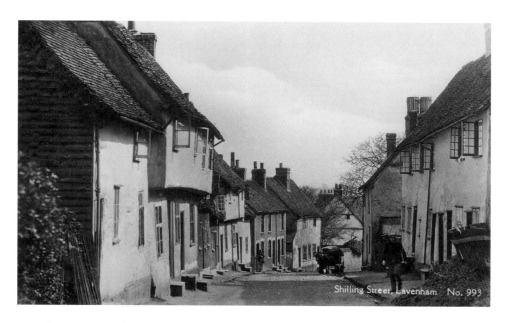

Shilling Street, Lavenham No. 993

Prentice Street, Early 1930s

Running from Market Place down the hill to Lower Road is Prentice Street whose name came from the medieval wool apprentices who once gathered in this road. In the mid sixteenth century, the Guildhall of Holy Trinity was built but – demolished in 1879. Today in its place stands one of the village's car parks and public conveniences. The road is full of buildings from Lavenham's medieval wool riches and its Victorian industrial past. Thomas Baker (died in January 1892 aged sixty-two) had followed his father's footsteps as a miller and maltster of Lavenham, and also had farms in Lavenham, Brent Eleigh and Milden. He built the industrial mills and maltings in Prentice Street, along with his own grand house. In 1986 Baker's mill and maltings were converted to residential use but retained its heritage by keeping the name Bakers Mill. The residential mill still has a foundation stone inscribed 'Built by J. W. and F. W. Baker': both were sons of Thomas. Inset: Thomas Baker's house with the mill to the left.

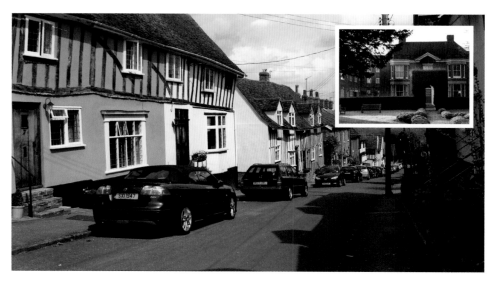

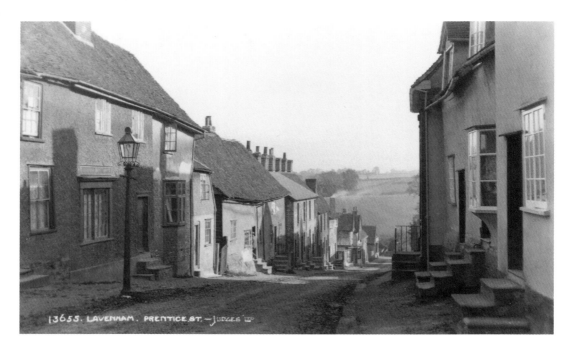

Shilling Street, 1920s

John Schylling was a wealthy wool merchant who built his medieval house, Shilling Grange, sometime in the late fifteenth century. The street was subsequently named after his Grange. In the centre-left of both images are three brick-built Victorian cottages (now painted in bright Suffolk colours), after which is a sixteenth-century building. The latter building was once one of Lavenham's pubs, The Conquering Hero, and believed to have been shut in 1856 when it was sold at auction along with the three cottages.

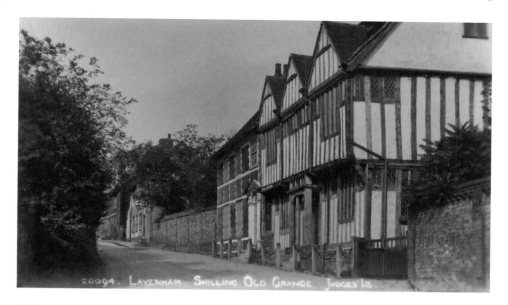

Shilling Old Grange, Shilling Street, facing Market Place, Late 1930s

Built in the fifteenth century, by the mid-1920s this outstanding building was derelict and about to be demolished. After an appeal in 1926 to save the building by the Society for the Protection of Ancient Buildings, a London architect, Percy Green, bought the Grange and extensively restored it at great personal expense. In the 1780s, The Grange was leased by Isaac Taylor (1759–1829) who paid £6 per annum rent. He lived here with his wife and children until 1796. His daughters, Ann (1782–1866) and Jane (1783–1824) became well known for their books of nursery rhymes. In 1806, the sisters published *Rhymes for the Nursery*, which contained, arguably, that most famous of English nursery rhymes, Jane's 'Twinkle Twinkle Little Star'. The book was published after the family's time in Lavenham when they were living in Essex, but locals claim that it was written while the family lived at The Grange.

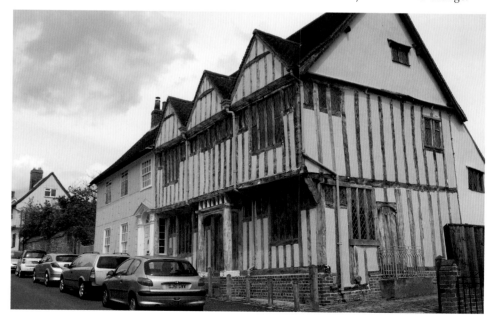

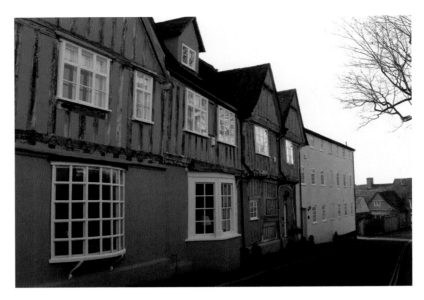

Grammar School and House-Hair Factory, Barn Street, 2015

This street runs from the Market Place in the north to Water Street in the South and named after a manorial barn which stood in the street until the 1860s. The top photograph is the Old Grammar School, which was built in the sixteenth century. In 1647 Richard Peacock established the building as a grammar school for boarding boys. The school's most famous pupil was the painter John Constable (1776–1837) who joined the school when he was eleven years old but was removed by his parents shortly afterwards because of the severe beatings metered out by the school. The building ceased being a school in 1887 and became a residential house. Attached to the Grammar School is the mid-nineteenth-century industrial building of a horse-hair factory (bottom photograph). The arrangement of these two buildings, built three hundred years apart, demonstrates clearly that Lavenham's medieval past nestles closely alongside its industrial heyday.

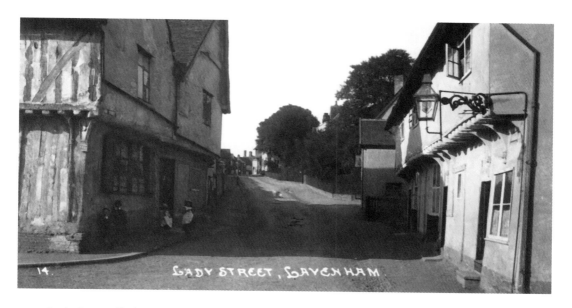

Lady Street (facing towards The Market), Early 1900s

On the left side of Lady Street is the Guildhall of Our Lady, also known as the Wool Hall, and now part of The Swan Inn. Opposite the Wool Hall are Nos 10 and 11 Lady Street, whose frontage is on Lady Street but extends into Water Street at its side. This was originally a range of medieval and Tudor shops built in the fifteenth and sixteenth centuries. The original Tudor shop front at the south end of the premises on Lady Street, with its doorway and three arched openings (now windows), was covered up under plaster by the time of the Edwardian photograph. Prior to its Grade I listing in 1958, the front was restored to its magnificent Tudor form. The building became a private residence in the modern times and restored again in the early 2000s. It was opened as a wine bar and restaurant by its owners in 2013. Inset: Lady Street's Tudor shops.

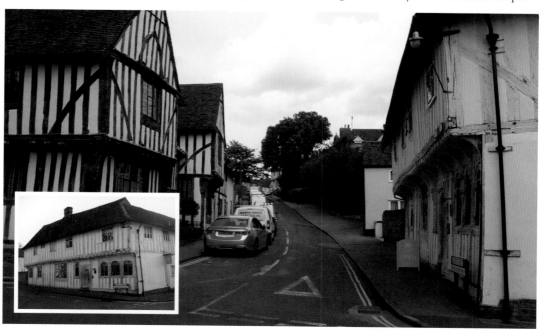

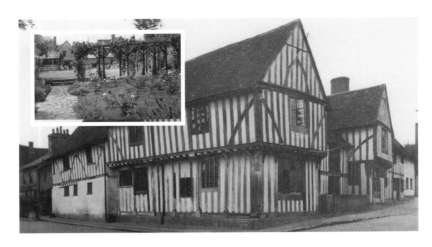

Wool Hall (corner of Lady Street and Water Street), *c. 1920s*

One of the four medieval/early Tudor guildhalls in Lavenham was the Guildhall of Our Lady. Predating the Guildhall in Market Place, this Hall was built in the latter part of the fifteenth century. It is unknown when it became the Wool Hall, but it is likely that it was around 1696. Around this date a middle gable was constructed into the building (visible in the Edwardian photograph on the previous page). Once the wool trade had declined in Lavenham, the hall was divided into three houses and a baker's shop. The fact that it still exists today in the village pays remarkable homage to the people of Lavenham in 1911 as it had started to be taken down piece by piece to be reassembled elsewhere – possibly America. After strong local protests, the Hall (two-thirds of which had been demolished by this stage) was saved by the Society for the Protection of Ancient Buildings. More remarkably, the Duchess of Argyll (Princess Louise, Queen Victoria's sixth child) purchased it and personally paid for it to be restored to its former medieval glory (minus the middle gable). Once the work was completed, Princess Louise gave the hall to be a convalescent home for sick railway women. After the closure of Lavenham's railway line in the 1960s, the Convalescent Home was closed in 1961/62 and the hall was purchased by Trust House Limited, who owned The Swan, in 1963. The Wool Hall is now part of the hotel. Inset: Garden of the Railway Convalescent Home, *c. 1920s*.

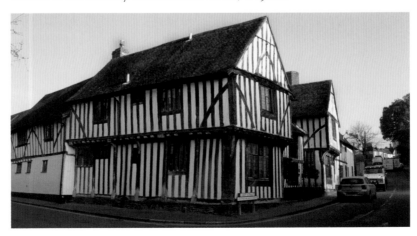

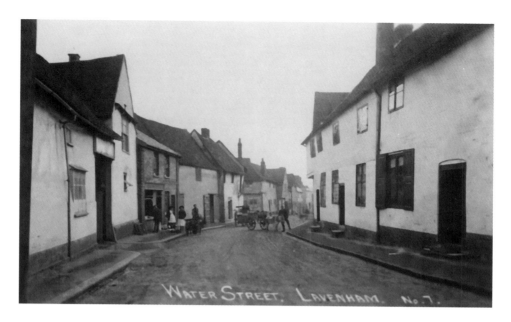

Water Street (facing away from the High Street), Early 1900s

At the junction from the High Street onto Water Street there is a range of buildings (on the left side) which were used in the Edwardian period as stabling and shops, but now are all part of the extensive rooms of The Swan. On the right side of the street are a range of shops built in the late medieval period known as Merchants Row. These were plastered over at some point (as shown in the Edwardian image) but restored during the 1980s to reveal their Tudor timbers and jetties. Water Street was thus named because of a tributary of the River Brett which flowed down the entire street. It was once thought that an enclosed brick culvert (a structure allowing water to flow under the road) was built in the late medieval period to channel this stream. However, research by English Heritage in 2007 proved that the culvert was dated from a number of periods starting in the early sixteenth century but it had been extensively improved and repaired over several centuries.

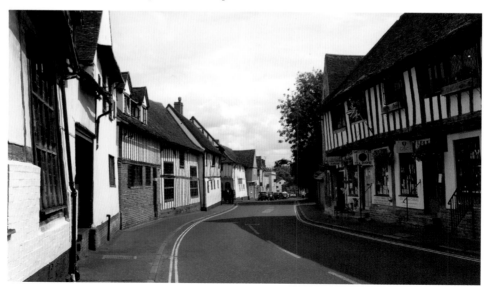

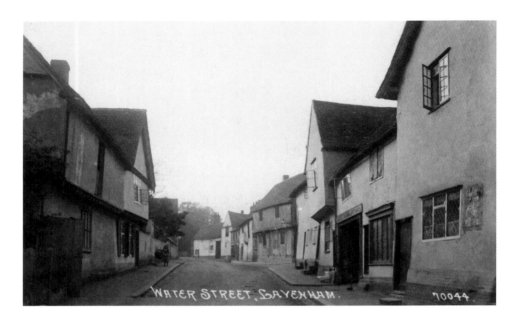

Water Street (facing towards the High Street), *c.* **1910s**

Like many roads in Lavenham, Water Street has many medieval buildings built on the success of the wool trade, which huddle alongside their more modern Georgian and Victorian counterparts built during Britain's industrialisation. Further down Water Street (behind the photographer in these images) is W. W. Roper's horse-hair factory, now converted into residential flats. The horse hair factory building still present in Water Street was built in 1891, but Roper's business was in the street from the mid-nineteenth century onwards. A popular local man and employer of many hundreds of Lavenham folk, in 1865 Roper won a contract to cover the floors of the House of Commons and the House of Lords at Westminster with horse hair matting made from short hair spun into yarn and then dyed olive and green. After the death of William Whittingham Roper in 1890, his sons continued his business – as can be seen by some of the dating stones on buildings in the top part of the high street. Inset: Roper's horsehair factory.

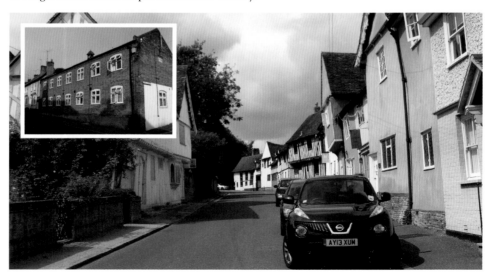

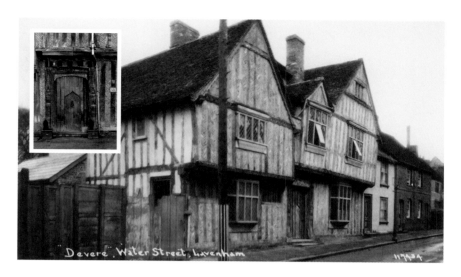

De Vere House, Water Street, *c.* 1910s

One of the village's most visited buildings is de Vere House. Long before the House became internationally famous as the birthplace of Harry Potter and the place where Voldermort killed his parents, de Vere House has attracted admirers from all over world. Originally the House was built in the fourteenth century by the powerful de Vere family, who owned the property until at least the 1670s. The ornate and beautiful carved doorway dates from around 1485. No mere coincidence that this is the same date as when its owner, John de Vere, the 13th Earl of Oxford, led Henry Tudor's troops to success at the Battle of Bosworth against Richard III. In 1926, Lavenham nearly lost this, one of its most exquisite buildings, when the majority of the de Vere House was dismantled and removed for reassembling elsewhere. Fortunately, after intense public outcry, the new owner rebuilt the house back in its original location at his own cost. Inset: De Vere House's ornate carved doorway – according to a recent newspaper, one of the most photographed doorways in Britain.

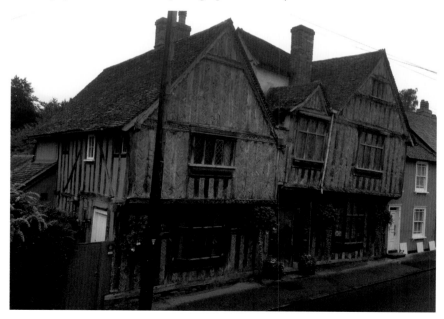

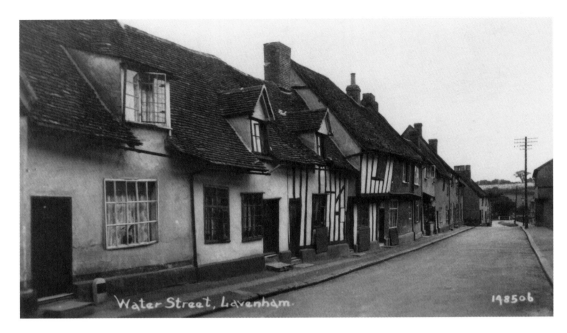

Flemish Weavers Cottages, 23–26 Water Street, *c.* 1920s/1930s
With parts dating from the 1340s, this row of small cottages are some of the oldest dwelling-places in Lavenham. The chimney visible on the left edge of the modern photograph was built at a later time than the cottages. Known locally as the Flemish Weavers Cottages, it is unclear if Flemish weavers did, indeed, come to Lavenham and if so, when. F. Lingard Ranson, writing in 1965, stated that the cottages were almost derelict by the 1950s and were restored in 1956–57.

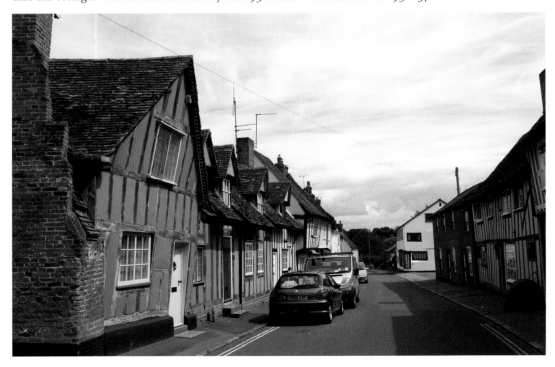

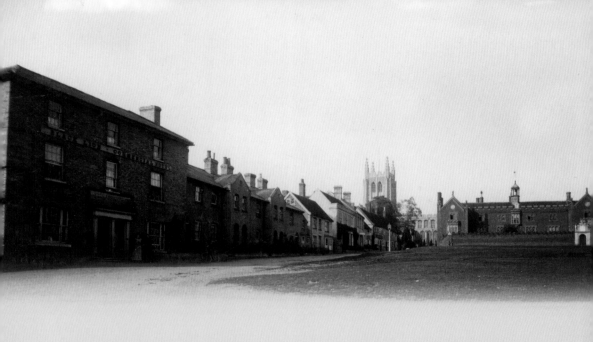

CHAPTER 4

Long Melford

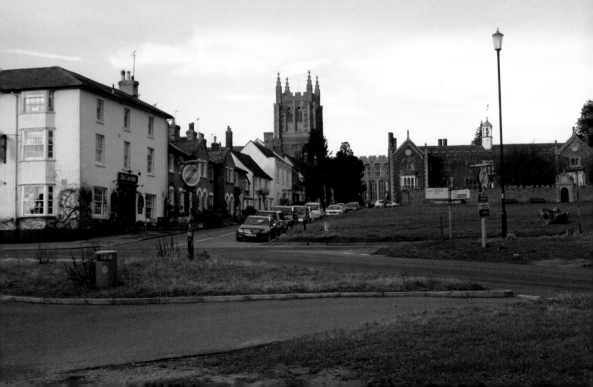

High Street, 2015

When passing through Long Melford, it is easy to determine how the village got its 'Long' prefix. With a single continuous road starting at the High Street in the north, it carries on for nearly a further three miles through Hall Street before finally ending at St Mary's in the south. It is England's longest village. Most English towns and villages have their largest concentration of shops within a road named the High Street. However, in Long Melford's case, although the start of its major road is thus named, its shops are no longer located here, but further down in Hall Street and St Mary's. While there are no modern shops in the High Street, there are a wide range of buildings from all periods showing that this area of the village has been used throughout its history. These buildings include farms, former bakeries, workmen's cottages and medieval buildings. The local pub, the Hare Inn (in the distance of the top photograph) has served this area of Long Melford for over three hundred years.

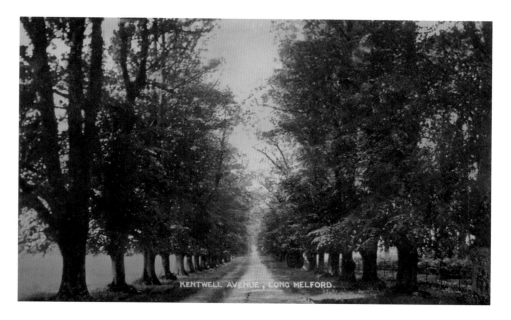

Kentwell Avenue, Postmarked 1910

First planted in the late seventeenth century, the lime trees in Kentwell Avenue lead to the entrance of Kentwell Hall. According to Ernest Ambrose's memoirs about his late Victorian childhood, on a Sunday afternoon entire local families perambulated the ¾ mile length of the Avenue politely chatting to their neighbours, whispering the latest scandal from the village. The avenue was also used by young couples who were 'walking out' (chaperoned) with the status of their relationship plain to view. If they were lightly holding hands, then they had just started courting. But if the man had a pheasant feather stuck in his cap and the couple were walking arm-in-arm, then they were engaged. Ernest also recalled how locals collected mistletoe from Kentwell Avenue to bedeck their houses at Christmas.

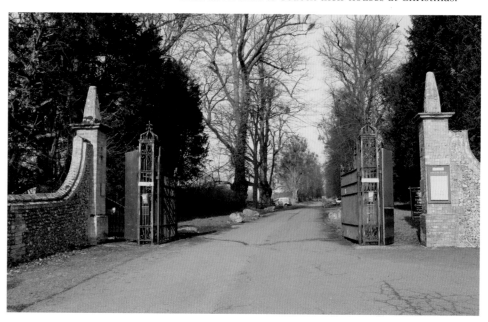

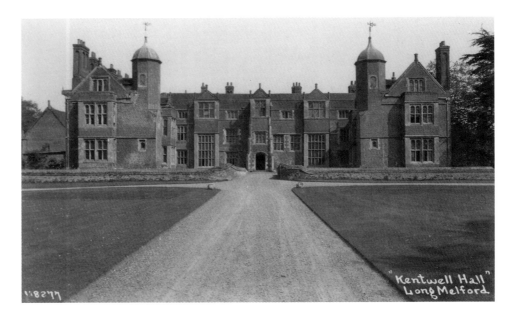

Kentwell Hall, *c.* 1920s/1930s

Kentwell Hall is one of two great manorial houses within the village of Long Melford. The current hall was built between 1500 and 1550 by the Clopton family, although the first Clopton came to the village in 1385 after his marriage to the owner of the estate. The house then stayed in the ownership of the Clopton family until the seventeenth century after which time it passed into the hands of several families. Today, still in private ownership, the hall is renowned throughout England for its regular re-enactments and staging of Tudor life. During many holidays and festivities, such as Easter, Christmas and Michaelmas, the hall and gardens are filled with The Tudors who all demonstrate Tudor methods (such as cooking, butter making, wool spinning and dyeing) to visitors. Visiting the hall during one of these re-enactments is a highlight to many Tudor history enthusiast. The hall also stages regular days for schools and home-educated children: dressing up as a Tudor to attend Kentwell Hall is many a modern-day East Anglian child's first encounter with the world of the sixteenth century.

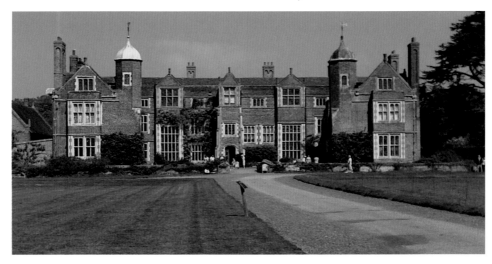

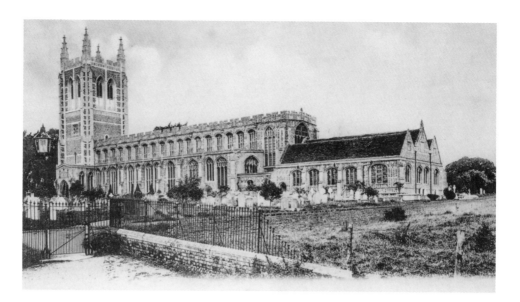

Holy Trinity Church, Early-1900s

Holy Trinity Church is one of Suffolk's impressive wool churches and was built on the wealth of the medieval wool trade which flourished in East Anglia. There has been a church on this site since at least the time of King Edward the Confessor (reigned 1042–1066). The present church was constructed between the 1460s and 1490s on the money of wealthy wool merchant, John Clopton of Kentwell Hall (*c.* 1423–1497). On 30 June 1701, lightning struck the medieval tower causing it to collapse and damage the church. The cost of the damage to both the tower and church was estimated at upwards of £1,800. The tower was rebuilt by Daniel Hills (architect) between 1712 and 1725 from brick with a lantern at the top. The tower was finally rebuilt again between 1897 and 1903, when the current tower was constructed in the Victorian Gothic style designed by George Bodley. An impressive church with its length more in common with a cathedral than a parish church, its length (including the remarkable Lady Chapel) is just short of 250 feet.

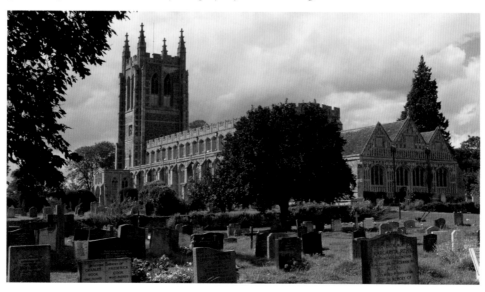

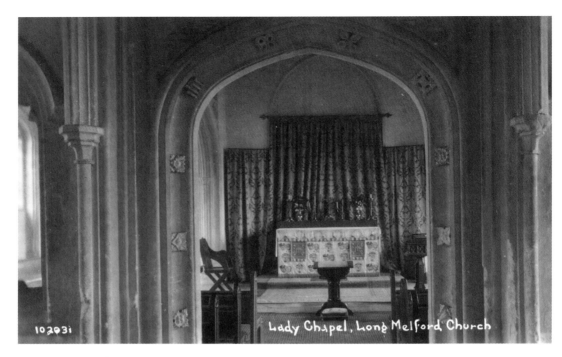

Lady Chapel, Long Melford Church

102031

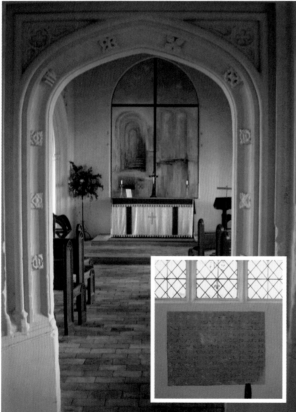

Lady Chapel, Holy Trinity Church, c. 1920s

Unusually for an English parish church, Holy Trinity Church has a Lady Chapel attached as a separate side building, and located at the east end of the main church. Lady Chapels are more commonly associated with cathedrals or abbeys, not parish churches. Holy Trinity's Lady Chapel was built in the 1490s by John Clopton who originally built it as a chapel to contain his family's tomb. However, his wife died before its completion so the Cloptons were buried inside the church. From the late seventeenth century until the 1860s, when the National School was built nearby, the chapel was used as a free school for the education of ten poor boys. The altar-piece shown in the modern photograph is a mural commissioned and painted by Alison Englefield in 2011 by the Friends of Long Melford church and entitled The Way Through. Inset: The multiplication table in the Lady Chapel, used during the period the chapel was a school.

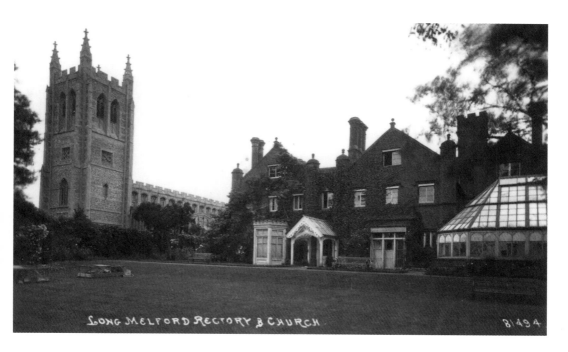

Rectory, c. 1920

The Rectory, also known as Montgomery House, was built in the late nineteenth century of red brick mimicking the style of the nearby Elizabethan Trinity Hospital. A deed of conveyance dated 1946 between Revd Charles Sydney Hardy, William H. Pearman (both of Long Melford), the Ecclesiastical Commissioners for England and Dr Barnardo's Homes documents that Montgomery House was bought by Dr Barnardo's for £400. The House was used as a Barnardo's children's home from January 1947, until the home closed in November 1967. After this time, it became a nursing home for the elderly until the 1990s, but is now a private residence.

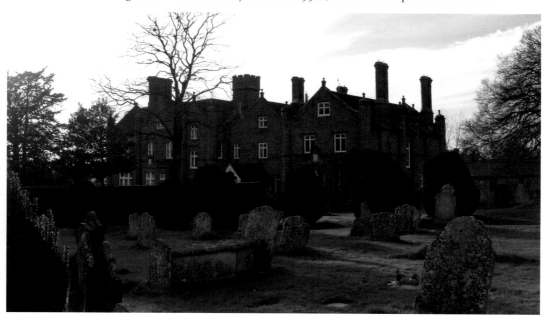

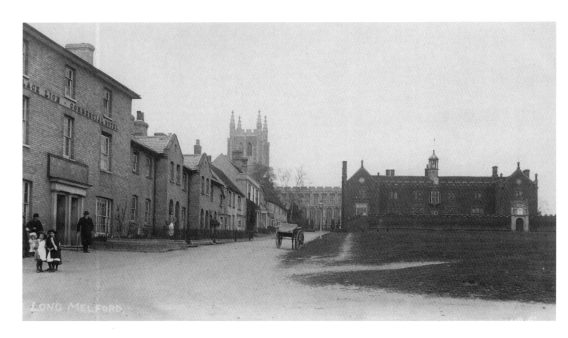

Black Lion Inn and Trinity Hospital, Church Walk, Early 1900s

The Black Lion, in Church Walk, has been at this location since at least the 1660s (although more likely since at least the fourteenth century). The present building was built in 1839 by Robert Harris. According to local newspaper advertisements placed by the Black Lion in the 1760s, the old inn had a bowling green which was free to use 'every day except Thursdays' (when, presumably, it was shut). In 1838, prior to the rebuilding of the Black Lion, the Inn was advertised for sale and described as having 'Outbuildings and Stables for 20 Horses, a detached Cottage and a Garden and a Paddock of nearly an Acre'.

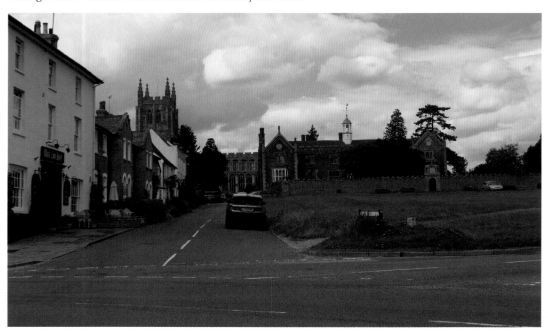

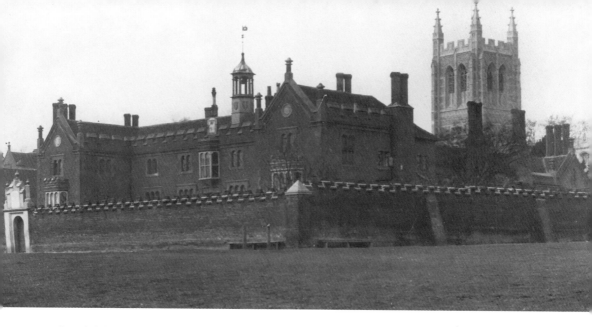

Holy Trinity Hospital, Postmarked 1909

In 1573, Sir William Cordell of Melford Hall founded the Holy Trinity Hospital which was built on the southern edge of the churchyard. The hospital (or almshouse) was to house twelve poor men (each at least fifty-five years old) who were born in Melford, or had dwelt in the village for a least two years. They were served by male warden, and two women, one was the laundress, the other was the cook and dairy-woman. The inhabitants were called the brethren. Sir William endowed the Hospital with 772 acres of land mainly in the nearby village of Shimpling. The Hospital continues today as an almhouse overseen by three trustees (appointed by Long Melford Parish Council) who serve for four years. The entrance criteria has changed since the time of Sir William: men, women and married couples now allowed to reside at the Hospital. Inset: Plaque on the side of the Hospital.

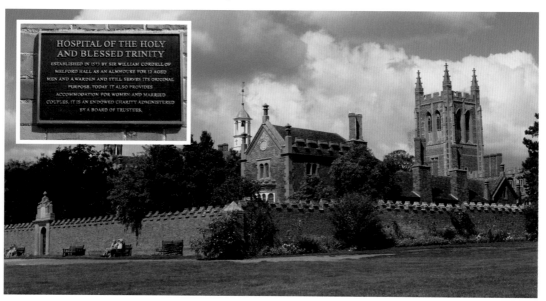

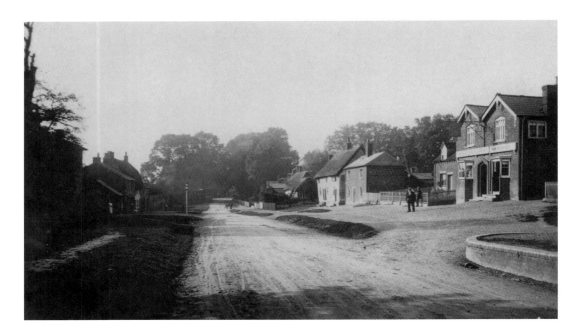

Westgate Street, Postmarked 1924

On the right of these pictures is the Scutchers Arms, formerly known as the Stag Beerhouse, and is now a restaurant. The building is timber-framed dating from approximately the fifteenth century but refaced in the late eighteenth/early nineteenth centuries. The term 'scutching' is connected to the process of releasing fibres from raw flax which were then sent to Ireland make Irish Linen. This process was done locally at a flax mill in Long Melford, hence the pub's renaming in the nineteenth century. According to oral histories of the village, in the early part of the twentieth century the Scutchers Arms also had a bakery and it cooked local families' Sunday roast dinner and Yorkshire pudding for a fee of 4d per family.

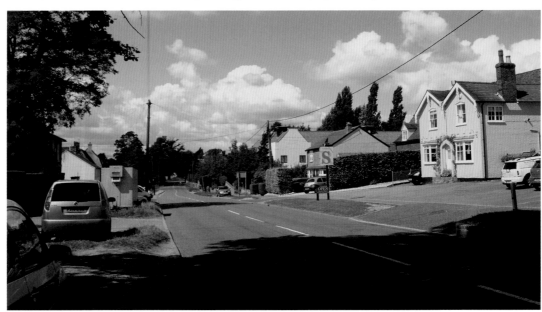

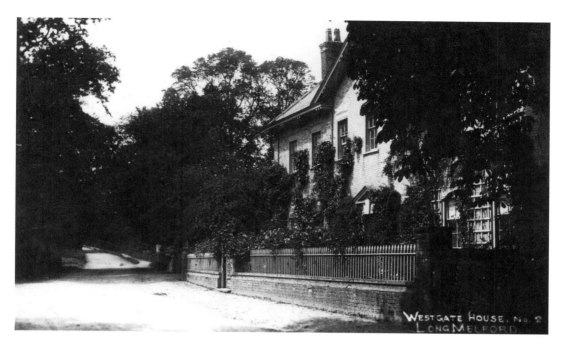

Westgate House, Postmark 1926

Westgate House, now known as Westgate Park, was built in the nineteenth century but remodelled in the twenty-first century. It is now a large country estate including equestrian facilities with an Olympic size dressage arena. In 1821, local newspapers advertised that the House was available to lease to a 'genteel family'. The accommodation then included 'appropriate domestic offices, yards, coach-house, good stabling for several houses, large garden walled in, well stocked with fruit trees and about 10 acres of excellent pasture land'.

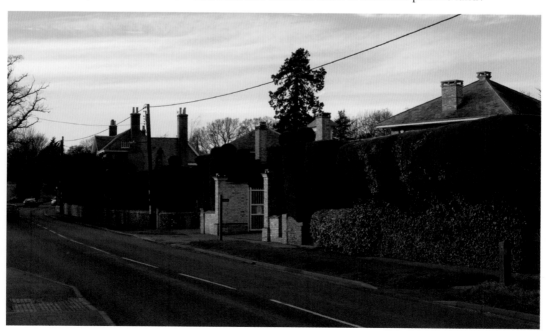

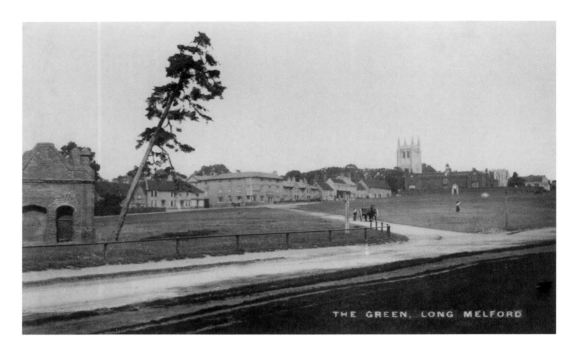

THE GREEN, LONG MELFORD

The Water Conduit and the Green, *c.* Early 1900s

The water conduit on Melford Green was built of red brick during the sixteenth century and the upper part of the building restored in the nineteenth century. Financed by Sir William Cordell, it channelled a nearby spring to supply Melford Hall with water. The view by the conduit looking back up to Holy Trinity Church shows that the famous big Suffolk skies are very much evident in Long Melford.

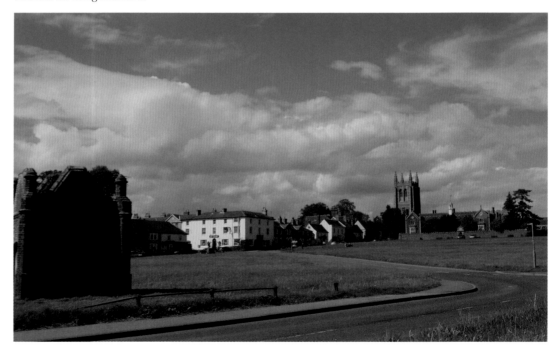

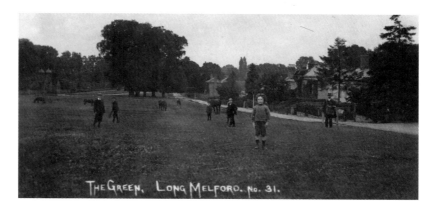

The Green, Early 1900s

From the 1960s onwards, various societies throughout Suffolk recorded oral interviews with the county's residents. These recording lay forgotten and gathering dust all around Suffolk in various locations, until Heritage Lottery Fund awarded Suffolk County Council a substantial sum of money to collect the recordings together and digitally restore them. In the 2010s, Suffolk Voices Restored became available and in among all the recordings are incredible oral testimonies of life in Long Melford in the early part of the twentieth century. One resident, Mr Dury, recalling his Edwardian childhood recollected the gas lamps on Melford Green which were lit by the gas lighter who put them out each night at midnight. He also remembered that the young men of the village played football on the green at night and that there was a May Pole outside the National School. Several residents remarked about local celebrations on the green, including a big fire for Guy Fawkes Night on 5 November lit from faggots local lads took from a nearby bakery. A popular topic discussed by residents was the Melford Fair which took place each Whitsun on the green. Mr and Mrs Mills recalled the Edwardian fairs and how the village became full of gypsies, peddlers and travellers, some of whom ran horses up and down the street alongside the green, and many violent fights took place. The Mills also reminisced that they always had the day off school to attend the fair which took place on Thursday, Friday and Saturday after Whitsun. These were big fairs, and attracted people from all over the nearby countryside. The fairs included the buying and selling of cattle and horses, along with fun rides and coconut shies. There were cockles and whelks from Lowestoft and Great Yarmouth, along with food stands outside Black Lion Inn. The bottom part of green was used to show agricultural implements from David Ward's foundry. There is still a Whitsun fair on Melford Green even to this day, but not as large as it was a hundred years ago.

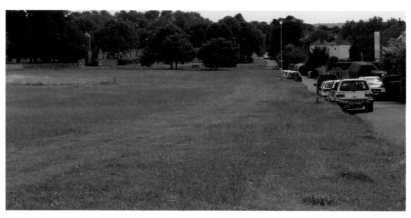

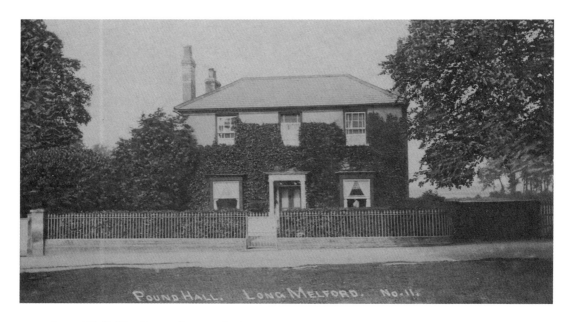

Pound Hall, The Green, Postmarked 1911

In November 1865, there was much excitement in Long Melford when the Prince and Princess of Wales (later King Edward VII and Queen Alexandra) paid a visit to Melford Hall. Local newspapers were full of reports about the visit and the extraordinary lengths people went to decorate their houses in patriotic regalia. In particular, houses around the green and Melford Hall were vividly festooned. Pound Hall, then owned by a Mr Charles Vinings, was mentioned in many newspapers. The Hall displayed a 'variety of very tasteful decorations' including the Prince of Wales' plume hung over the entrance with each column on the portico decorated with wreaths, the house had numerous Union Jacks and all along the garden wall there were a number of 'very chaste small silk flags'.

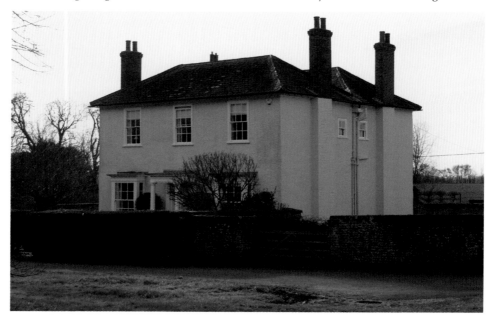

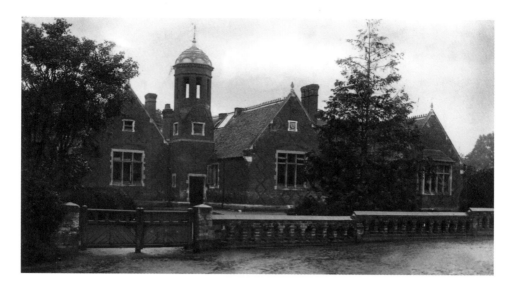

The School, Postmarked 1908

Now known as the Old School, Long Melford's National School was built in 1861. The National School system was set up in 1811 and used throughout England as a method of educating poor children under the guidance of the local Church of England church. According to Ernest Ambrose's memoirs, in the 1880s his father paid the sum of one old pence per week for his attendance. As it was a church school, Ernest recalled that the rector or curates of Holy Trinity Church visited the school every Friday to give Bible lessons and hear the children recite Biblical lessons. By the early 1900s, Long Melford's National School had two hundred boys, two hundred girls and hundred infants on its registers. In 1895, another infants' school was built in St Catherine's Road. The schools were eventually absorbed into the English state primary school system and remained as the village's schools until the 1970s, when the old National School was shut in 1974. The large millstone at the front of the building has a brass plaque inscribed: '1899–2002 Dedicated to all those who worked for Bush Boake Allen Ltd, formerly Stafford Allen & Sons at Stafford works Liston, Long Melford'.

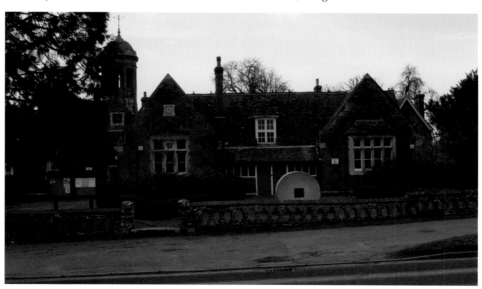

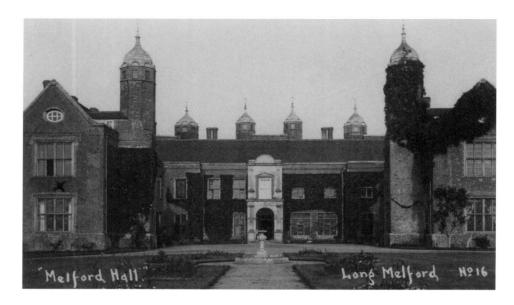

Melford Hall, Early 1900s

At the time of William the Conqueror's great tax survey of 1086, Domesday recorded that the lord of the manor of (Long) Melford was the abbey at Bury St Edmunds. The abbots held the land until Henry VIII's Dissolution of Monasteries of the late 1530s, at which time the ownership of the manor was seized by the king. In 1554, Sir William Cordell (1522–81) bought the manor from Henry VIII for the sum of £802 3s 4d and built the current Melford Hall. In 1578, Elizabeth I stayed at Melford Hall during one of her lavish yearly summer progresses through East Anglia. In 1786, the Hall was purchased by the Parker family and descendants still live at the Hall today. Sir William Hyde Parker (1863–1931) married Ethel Leech, who was a cousin of the children's author and illustrator Beatrix Potter, who became a regular visitor to the Hall where she painted watercolours of the Hall. In 1960, the care of the Hall was given to the National Trust and the Hall is now open in the summer months to visitors from all over the world. Inset: The gatehouse to Melford Hall was built in 1838 in the same style as the Tudor Hall. Estate workers families lived in the gatehouse until at least the 1930s. It now contains the National Trust's reception, shop, plant shop and visitors' toilets.

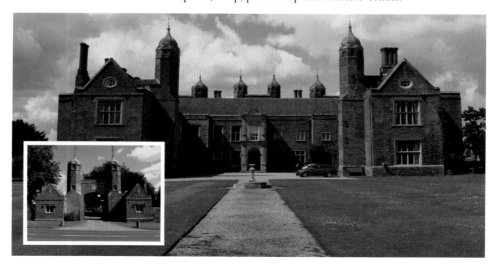

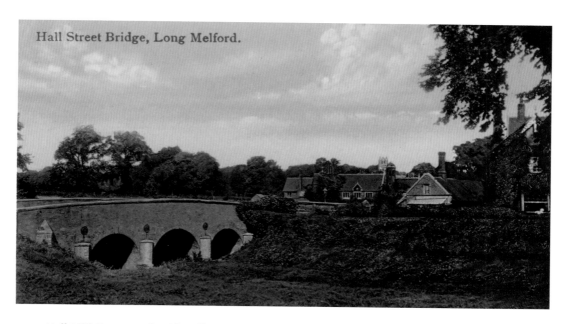

Hall Street Bridge, Long Melford.

Hall Mill House and Bridge (facing towards the Church), Postmarked 1917
One of the two mills detailed in William the Conqueror's Domesday Book of 1086, this mill was once part of Melford Hall's estate and is the mill which gave Melford its name. In the middle of the sixteenth century, a grant of lands given by Sir William Cordell of Melford Hall shows that there was a mill still present at this location. It has long since been demolished. The current bridge over the Chad Brook was built in the eighteenth century. The view of bridge and Mill House is the same now as in Edwardian times, but the all year round thick and dense undergrowth makes it impossible to take a modern-day equivalent photograph and so the modern image was photographed from the top of the bridge. Edmund Blunden (born 1896), the famous poet from the First World War and author of the classic *Undertones of War* lived in the Mill House and died there in 1974. He is buried in the churchyard of Holy Trinity. Inset: The foot bridge (facing away from the church).

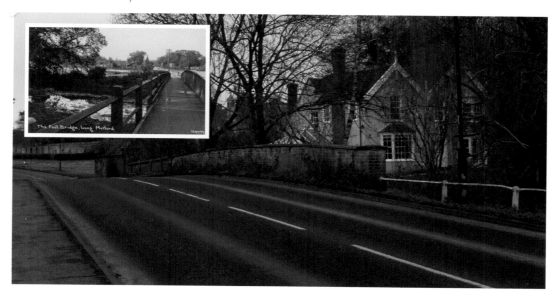

The Foot Bridge, Long Melford.

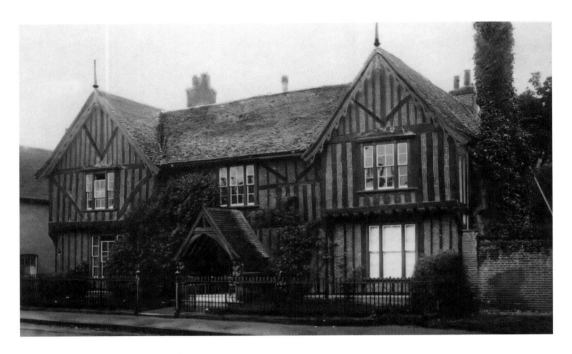

Brook House, Hall Street, Early 1910s

One of the oldest houses in Long Melford is Brook House (opposite the Bull Inn) with the original house built in *c.* 1490, but later faced with brick nogging during the nineteenth century. Its porch bears the date plaque of 1610. It was documented as being the Harte Inn in a manorial map of Melford dating from 1618. In the late sixteenth century/early seventeenth century the innkeeper of the Harte was a William Dash, who also leased the Hall Mill.

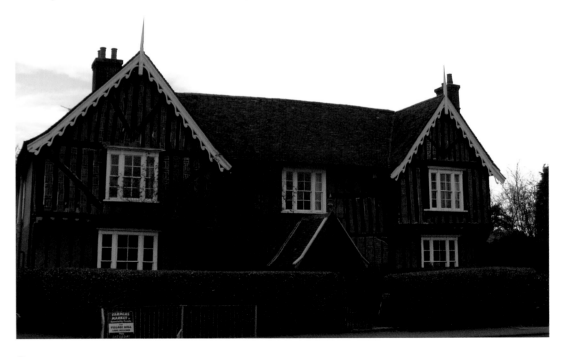

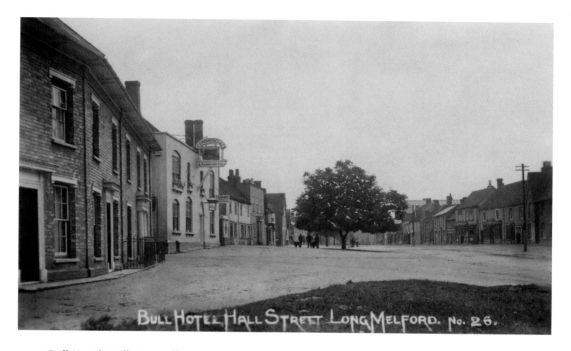

Bull Hotel, Hall Street (facing south), *c.* 1920s

The Bull Hotel is Long Melford's most well-known pub and hotel. A manorial map of the 1580s demonstrates that the inn has been here since at least the Elizabethan age but the inn was possibly at this location from the fifteenth century onwards. A timber-framed building, the façade seen in the top photograph was built onto the building in the 1820s but removed in 1935. According to some reports, the ghost of a former guest, Richard Evered, who was murdered in the hotel in the 1640s is alleged to still haunt a room in the Inn. As yet, the author, who has spent many a night in this hotel, has yet to spot the ghost flitting through the inn. Inset: The modern-day restored frontage of the Bull Inn.

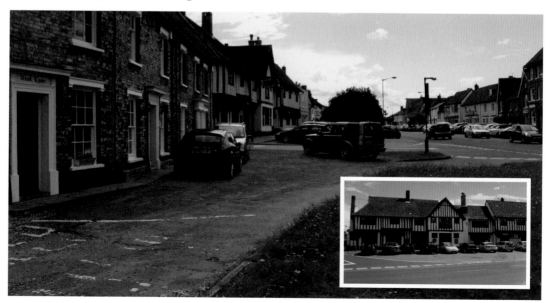

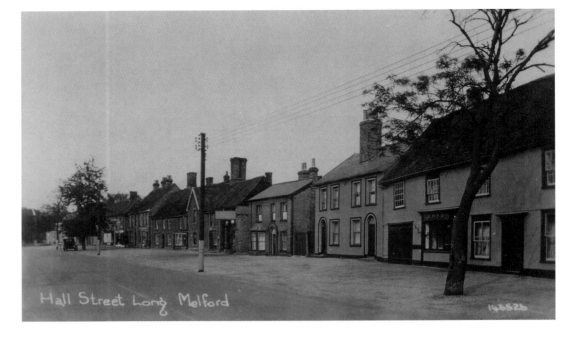

Hall Street (facing north) *c.* 1930s

Long Melford has a lengthy history of supplying its villagers with all their needs. Trade directories from the Victorian and Edwardian eras demonstrate that present in the village were the proverbial butchers, bakers and candlestick makers. Along with boot makers, chimney sweeps, a bill poster, a town crier, builders, surgeon, chemists, plumbers, carpenters, grocers, drapers, blacksmiths, hair dresser, sadlers, hardware dealers, whitesmiths, solicitors, bankers, and glaziers (to name but a few of the village's trades). One of the village's longest serving businesses is that of the family Ruse the butchers, who have been present in the village since 1860.

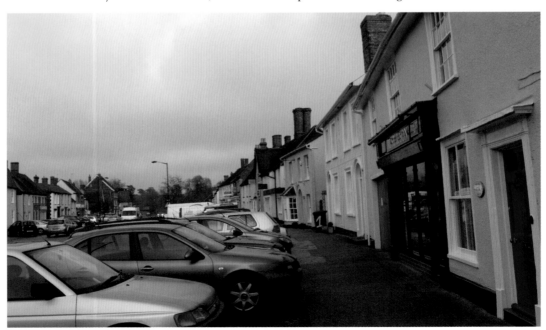

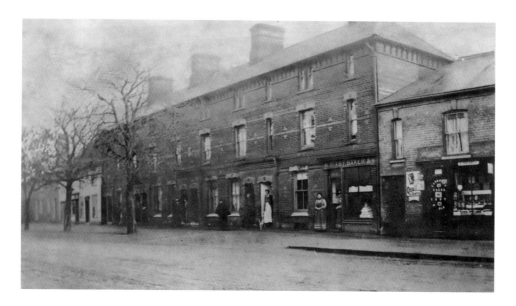

Chestnut Terrace, Hall Street, Postmarked 1904

Long Melford has always been very much a working village with a rich Victorian industrial past and heritage. David Ward set up his iron foundry in 1843, by the 1850s there were three horsehair factories, and at least four malthouses by the end of the nineteenth century. George Whittle set up a cocoanut matting factory in the mid-nineteenth century, and the village also had a flax mill. These Victorian industries employed many local people. Chestnut Terrace, built in 1868, was built as a terrace of houses for the Victorian workers of Long Melford. Census returns from 1871 reveal that the terrace was inhabited by shoemakers, carpenters, joiners, factory labours, mat weavers and upholsterers.

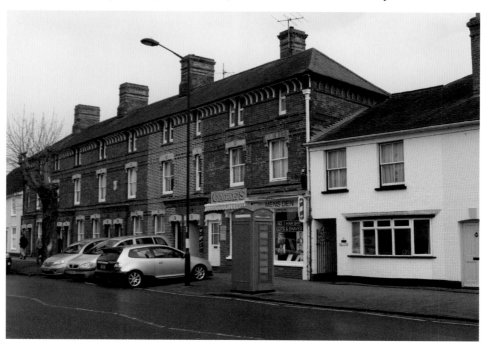

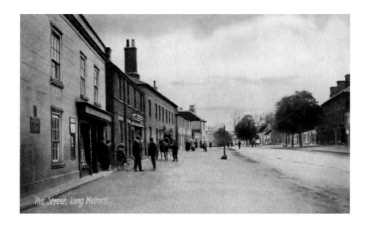

The Post Office, Hall Street (facing north), Early 1900s

The views of sleepy Long Melford with locals casually standing outside village shops hide some of the darker sides of the village's past. During the last quarter of the nineteenth century there was a downturn and depression in the English agricultural economy. This led to much hardship and tensions within English villages. Long Melford felt the effects of this economic downturn with strikes in the cocoa-nut mat factory in the 1880s. There were also tensions between the villagers of Long Melford (largely a Conservative village) and the next door village of Glemsford (a Liberal stronghold). These tensions overflowed in 1885 when there was a General Election on 1 December. Unfortunately, there was no polling station in Glemsford, so on Election Day, a crowd of about four hundred Glemsford men marched the three miles into Long Melford (where there was a polling station) to vote. According to newspaper reports, the men 'marched in fours, preceded by a band and Henry Cook [manager of a mat-factory in Glemsford] on horseback'. Another newspaper account said the Glemsford men were 'bedecked in yellow, the colour of the [Liberal] candidate in whose favour they were'. By the time they reached the middle of Long Melford, a full violent and bloody riot between Glemsford and Long Melford men was in full swing. At some point the Riot Act was read by Captain Bence of Kentwell Hall. The crowds had to disperse immediately or face being arrested and charged with being 'riotously and tumultuously assembled together to the disturbance of the public peace'. However, Captain Bence was unable to make himself heard above the roar of the crowd, so the vicar, Revd C. J. Martyn had to finish reading the Act.

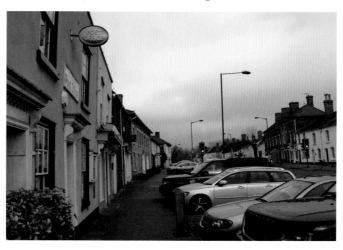

Sir William Cuthbert Quilter, MP for Sudbury 1885 to 1906, Postcard From His Failed Attempt of Re-Election in 1906

Despite the reading of the Riot Act, the rioting in the village continued on the 1 December 1885 and became increasingly aggressive with many violent acts against the local police. One policeman suffered injuries so severe that it seemed likely that some rioters would be charged with his murder. According to one eyewitness report, William Cuthbert Quilter, the Liberal candidate, arrived in Long Melford in his carriage. Driving in from the opposite direction to Glemsford, his presence caused the Glemsford men (except their leader, Henry Cook), in the process of marching out of the village, to wheel around to meet him, and re-enter the village to riot further. Quilter tried to lead the Glemsford men out of Long Melford, but they refused to follow him. Long Melford police urgently telegraphed for help and, at about 5.00 p.m., soldiers from Bury St Edmund's barracks arrived in Long Melford by train, and marched into the village with fixed bayonets, clearing out all the pubs. Their presence ended the riots. The damage to buildings in Long Melford was considerable: at the Petty Sessions held that year, the bench heard claims from various residents made against the Babergh Hundred. The largest single claim was for the Crown Inn, for which its landlady, Mrs Claydon, put in a claim to the value of £137 15s 6d as the building was, in the main, destroyed because it had displayed blue Tory posters. In addition to claims for damages, many men from both villages were tried for criminal acts. Those convicted were given sentences of hard labour ranging from twenty-one days to six months. However, Henry Cook was not convicted; instead, remarkably, the local Liberal party stood by Cook, and raised money to be used for his and other rioters' defences at the Suffolk Winter Assizes in Ipswich. In time, the blame was laid fully onto the local council for not having a polling station in Glemsford.

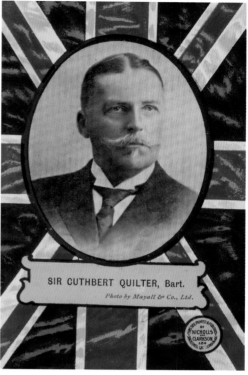

SIR CUTHBERT QUILTER, Bart.

Photo by Mayall & Co., Ltd.

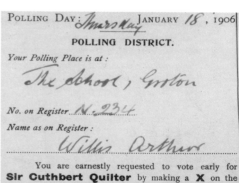

POLLING DAY: *Thursday* JANUARY 18, 1906

POLLING DISTRICT.

Your Polling Place is at :

The School, Groton

No. on Register... *N. 234*

Name as on Register :

Willis Arthur

You are earnestly requested to vote early for **Sir Cuthbert Quilter** by making a **X** on the Ballot Paper in the space to the right of his name, thus :—

1	ARMSTRONG	
2	QUILTER ...	X

Do NOT SIGN YOUR NAME OR PUT ANY OTHER MARK than one **X**, or your vote will be lost.

Fold the Ballot Paper and put it into the Box.

If you spoil a Ballot Paper ask for another.

After voting, kindly give your number to a member of Sir Cuthbert Quilter's Committee outside the polling station.

Hours of Poll - from 8 a.m. to 8 p.m.

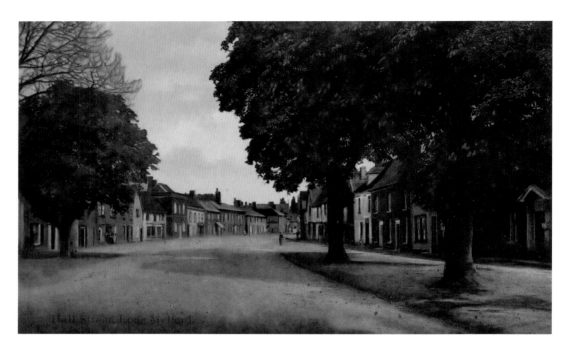

Hall Street (facing north), Postmarked 1909

Long Melford is one of the prettiest villages in Suffolk, if not in East Anglia. One attractive feature is the abundance of trees which line the village's wide main street along its entire stretch. With Tree Perseveration Orders protecting lime trees, an impressive plane tree, along with cherry, hawthorn and apple trees, the appeal of this road will remain for future generations. The majority of the modern-day photographs of the village had to be taken during the bleak winter months when each tree's foliage had naturally died back revealing Long Melford's buildings. The Edwardian photographers appeared to have photographed during the summer months, they having had less problems with abundant greenery (and cars) then modern-day cameras.

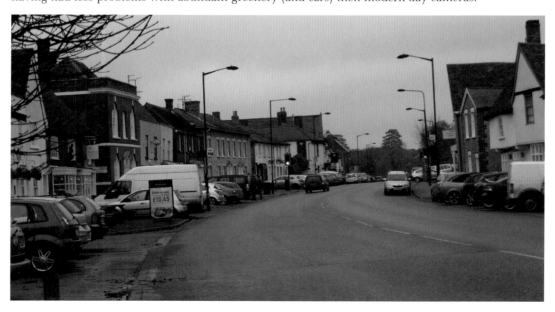

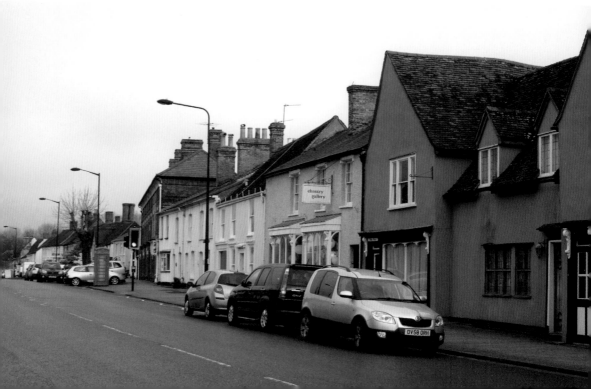

Hall Street (facing north), 1907
Sometimes, the text on the back of
postcards give a tantalising clue as to
the subject of the picture 'Dear Charlie,
I have sent your old girl's photo hoping you
will take care of it. Love to all'. On closer
examination of the postcard, the "old girl" is
sitting in Hall Street outside Daniel Spilling's
saddlery shop – his sign just visible on the
above the shop frontage. Today, his saddlery
is a gift shop.

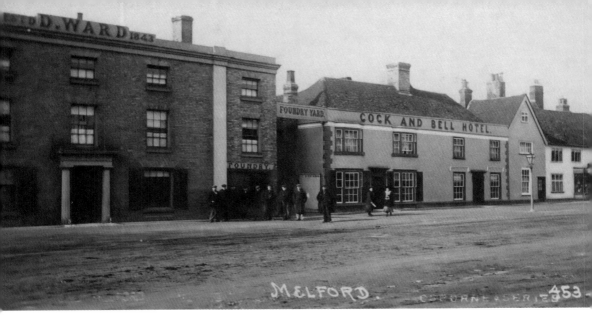

D. Ward Foundry and Cock and Bell Hotel, Hall Street, Early 1900s

David Ward set up his iron foundry in Long Melford in 1843, a few years later his brother-in-law James Silver joined him in the business. Later on in the nineteenth century, David Ward became one of the proprietors of a small gasworks company set up to supply the village with gas lamps in the street. Ward and Silver made some of the ironwork seen in monuments and grave markers in Holy Trinity churchyard. They also made more commercial items, such as ironwork on bridges on Clare Priory Bridge and Toppesfield Bridge (near Hadleigh). Some of the company's stamped small ironworks still regularly turn up in local auction houses.

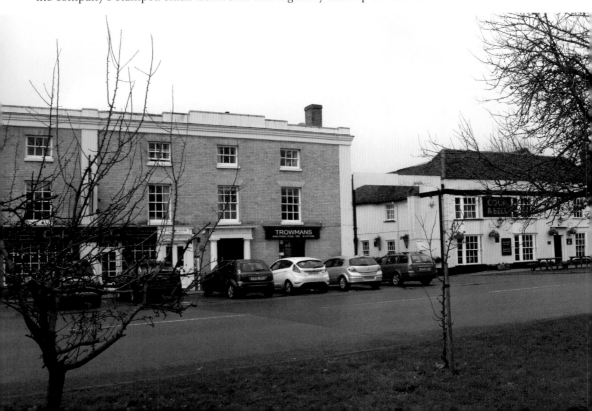

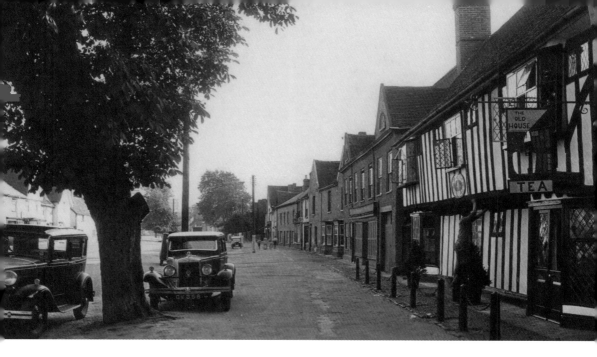

Hall Street (facing south), *c.* **1930s**
Originally a medieval hall house, this impressive building was a tea room in the 1930s, The Old
House Country Club in the 1950s and the Chimneys Restaurant in 1985. The restaurant closed
in 2010 and is now a private residence. It is believed that John Churchyard, who introduced the
horse-hair weaving industry into Long Melford, lived in the house during the 1830s.

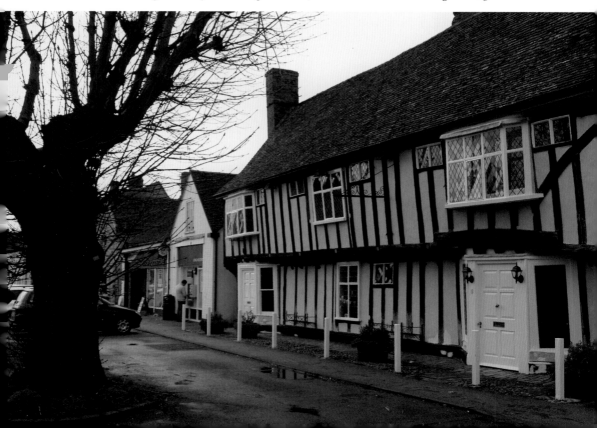

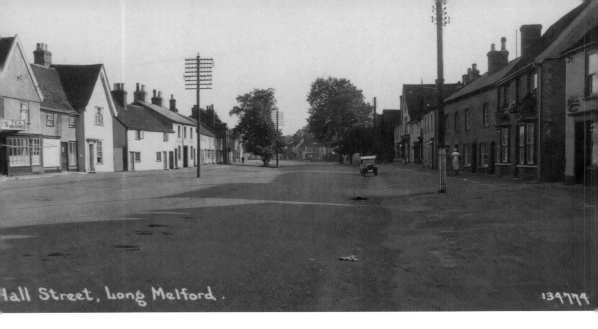

Hall Street, Long Melford. 139774

Hall Street (facing south), c. 1930s

One of the mysteries of Long Melford is its house numbering and naming system on the stretch of road from the Bull Inn in the north to St Mary's in the south. Many of the houses do have road numbers within Hall Street, but the majority commonly have either house names or a number within a small group of buildings. Names on this long stretch of road include those such as Theobald Cottages, Park Terrace, Dixey Cottage, Little St Mary's, the Old Cottage, The Cottage. The system is known only to those who live in the village, and locals tell tales of having to stand in the road to flag down an expected delivery van or guests. Shops and business shown in the photographs on this page all have Hall Street as their postal address but with house names such as the Posting House, Old Diary Place, Lime Cottage, Drury House, Dudley House, Aerial House. It is not easy tracking down a particular house or business in this part of Long Melford.

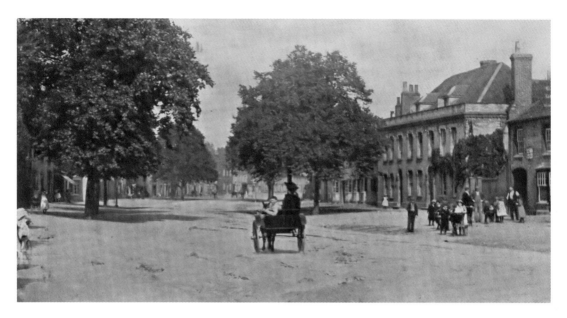

George and Dragon Pub, Hall Street (facing north), Postmarked 1905

The summer growth on the glorious plane tree on the left side of the Edwardian postcard hides two impressive Tudor houses: The Gables and Almacks. Both date from the sixteenth and seventeenth centuries but both houses had their fronts refaced with red brick during the nineteenth century. After the nineteenth century rework, the latter house was named after its Victorian owner: Henry Horn Almack. In the 2000s, Suffolk County Council Archaeological Service excavated land at the rear of The Gables and Almacks and found remains of the Roman settlement of Long Melford, including a second-century burial of a young woman. Inset: Almacks.

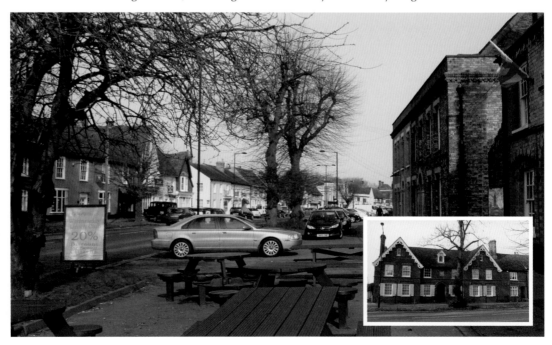

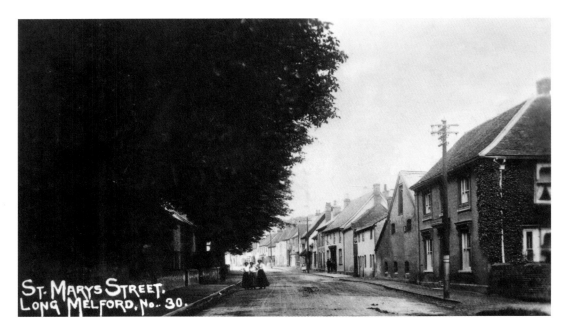

St Mary's Street/Little St Mary's (facing north), *c.* 1920s

The summer leaves on the trees of the postcard have mainly obscured the view of the pretty Grade II-listed flint cottages, Park Terrace, on the left. Behind the photographers and to the right is Chapel Green, where one of Long Melford's two medieval chapel-of-eases, St James's, once stood before the consequences of the English Reformation swept it away. Chapel Green was also the original site of Long Melford's market and fair whose charter was granted to the village by King John in the early thirteenth century. The market and fair later moved up the road to the green and this area became known as the Old Market from the mid-fifteenth century.

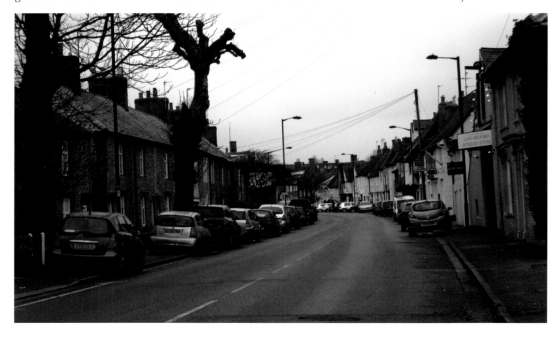

Bibliography

While writing *Sudbury, Long Melford and Lavenham Through Time*, the following books, reports, pamphlets and websites proved absolutely invaluable. This is by no means a complete bibliography, but simply the resources I consulted. To those historians who went before me, I owe a debt of gratitude.

Books and Reports

Ambrose, E., *Melford Memories: Recollections of 94 years*, (Long Melford, 1972)

Barbergh District Council, *Long Melford Conservation Area Appraisal* (Suffolk, 2011)

Betterton, A. and Dymond D., *Lavenham Industrial Town*, (Lavenham: Terence Dalton, 1989)

Boothman, L. and Parker, R. H., (editors), *Savage Fortune: An aristocratic family in the Early Seventeenth Century*, (Woodbridge: Boydell Press, 2006)

Darby, H. C., *The Domesday Geography of Eastern England* (Cambridge: Cambridge University Press, 1972)

Deeks, R. and Wigmore, E., *From Melford to Clare in Old Postcards*, (Melford: AP3 Gable End, 1994)

Deeks, R., *Magnificent Melford in Old Photographs*, (Long Melford: R. & K. Tyrrell, 1981)

Dyer, A., *Decline and Growth in English Towns 1400–1640*, (Cambridge: Cambridge University Press, 1991)

Fisher, D.R., 'Sudbury' from *The History of Parliament: the House of Commons*, (Cambridge: Cambridge University Press, 2009)

Fradley, M., Water Street, *Lavenham: A Desk-Based Assessment of a Brick Culvert* (English Heritage, 2007)

Hutchinson, R., *Young Henry: The Rise of Henry VIII* (London: W&N, 2011)

Page, W. (ed), 'Dominican friaries: Sudbury', from *A History of the County of Suffolk: Volume 2*, (London: Victoria County History, 1975)

Parker, W., *The History of Long Melford*, (London: Wyman & sons, 1873)

Ranson, F., *Lavenham*, (Lavenham: Ranson, 1965 edition)

Ranson, K., *Lingard's Lavenham: A photographic tour of Lavenham Past*, (Lavenham: Lavenham Press, 1991)

Ranson, K., *Lingard's Lavenham II: Lavenham Panorama* (Lavenham: Lavenham Press, 1992)

Suffolk County Council, *Archaeological Monitoring Report: Ballingdon Bridge* (Ipswich: Suffolk County Council Archaeology Service, 2002)

Suffolk County Council, *Land at Rear of 'Almacks', Long Melford*, (Ipswich: Suffolk County Council Archaeology Service, 2008)

Suffolk County Council, *Snell's Garage, Ballingdon Hill, Sudbury* (Ipswich: Suffolk County Council Archaeology Service, 2005)

Suffolk County Council, *The Gables, Hall Street, Long Melford*, (Ipswich: Suffolk County Council Archaeology Service, 2007)

Wallace, B., *Sudbury: History and Guide* (Stroud: The History Press, 2004)

Wigmore, E., *Holy Trinity Hospital, Long Melford: A 16th Century Almshouse* (Melford: AP3 Gable End, 1995)

Other sources

British Pathe film archives for Sudbury, Lavenham and Long Melford

Suffolk County Council's Oral History Project, Suffolk Voices Restored, (Suffolk Record Office, 2011)

Websites (all consulted April 2015)

British Library, The British Newspaper Archive, http://www.britishnewspaperarchive.co.uk

Foxearth and District Local History Society, http://www.foxearth.org.uk/index.html

Goodge, M., British Listed Buildings, http://www.britishlistedbuildings.co.uk

Palmer, J.J.N. and Slater, G., Open Domesday, http://www.domesdaymap.co.uk/

Sudbury History Society, Sudbury History, http://www.sudburyhistorysociety.co.uk

Sudbury Museum Trust, Caught on Camera, http://www.sudburysuffolk.co.uk/photoarchive/